BETTER PHOTO

[BL] British Library Cataloguing in Publication Data

Langford, Michael John
 Better photography.
 1. Photography
 I. Title
 770'.28
 ISBN (excl USA) 0 240 50983 8 (paperback)
 ISBN (USA only) 0 8038 0787 2 (paperback)
 ISBN (USA only) 0 8038 0789 9 (cloth)

First published 1978

Printed and bound in Great Britain by
A. Wheaton & Co. Ltd, Exeter

BETTER PHOTOGRAPHY

Michael Langford

Fellow and Senior Tutor in Photography
Royal College of Art, London

Focal Press · London

Focal/Hastings House · New York

CONTENTS

Diagrams by Roy Pickering

Acknowledgements This book has benefitted from many helpful reactions to '*Starting Photography*' from young learner photographers and their teachers. I also acknowledge the co-operation of teaching and technical staff of the Royal College of Art. Above all I am indebted to student photographers, whose work provides some of the illustrations on these pages. (In some cases it has not been possible to identify the original photographer from group work produced during photography courses. To these students I apologise, hope they will come forward, and not mind their work assisting others to learn.)

INTRODUCTION

This is a book for learners—particularly young people—who have already started taking pictures and know the absolute basics of black and white photography. It takes you on from the simple camera stage to explore the visual possibilities of picture composition, colour photography, creative use of lighting, lenses and film. And because it expects you to work at taking photographs there are some challenging projects and questions at the end of each section. Like the previous book 'Starting Photography' these are planned to help you link the theory and practice discussed in the text. All projects are open-ended, so everyone has plenty of scope for making their own original images, whether working singly or in a group. You don't necessarily need a lot of expensive equipment, because much of the book is concerned with learning to *see* and make visual decisions.

If you are preparing for school examinations in photography 'Better Photography' will complete the practical work needed for design and technique at ordinary level, and introduces topics such as basic colour photography for more advanced levels. Check your current syllabus against the contents of the two books—and don't overlook the definitions in the Glossary, designed particularly for examination use.

Better Photography begins by explaining the visual possibilities of wide angle and long focus lenses, offers a mini-course in lighting, including flash, and looks at the way the right choice of film and developer allow you to control the grain and contrast of the image. Colour photography is introduced from absolute basics, and includes processing your own slides at home.

The second, practical section of the book shows how to use colour as a vital element of composition, and relates the picture building aspects of photography to similar principles in drawing and painting. Special techniques often lead to unusual pictures as well as helping you to really understand darkroom processes. This section shows examples and gives step-by-step instruction on some of the most interesting effects. The final sections explore the building of picture sequences around themes (incidentally a regular type of examination question). This leads into the use of tape recorded sound combined with slide projection, which gives some exciting creative possibilities.

So the main function of this book is to issue challenges and suggest ideas and devices you will want to develop in your own way. One of the great strengths of photography is the way it involves you with real people, situations, structures, lighting effects etc. This means that you can't help becoming more aware of the things around you. Don't limit your photography to home or school (or worse still just admire the equipment). Better photography comes through practice at observing the world and making visual statements.

MICHAEL LANGFORD

1. The Better Use of Lenses

Most people start photography using a lens which is permanently fitted into the camera. Even if your camera does allow lens changing it is likely to have a normal or standard focal length lens when first bought. This is fine for most things, but means plenty of moving around each time you need more—or less—of the subject in your picture. The time comes when you just cannot approach near enough or move far enough away to get the best image. Nor will your single lens allow you the right perspective structure or dramatic emphasis for every situation. This is where wide angle and long focus lenses can really extend your photography, provided you understand what they will or will not do.

You can also experiment further

1.1 *The startling effect given by an 8 mm extreme fisheye lens.*

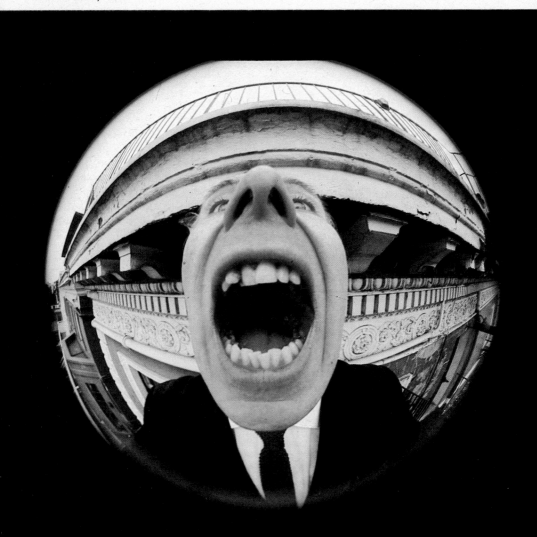

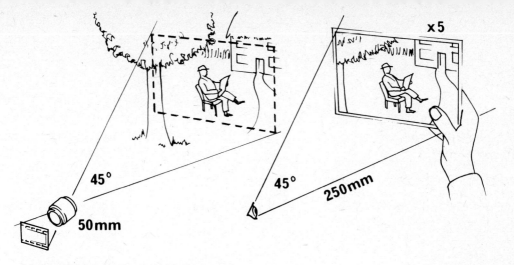

1.2 A 'normal' angle lens, and (right) an enlargement when viewed from normal reading distance has correct looking perspective.

with the ways position and extent of sharply recorded detail can be altered, using controlled depth of field and camera movements.

Normal lenses

The normal angle standard lens for a 35 mm film camera has a focal length of about 50 mm. This means that the lens has to be about 50 mm from the film to give sharp images of distant subjects. With the camera's 24 × 36 mm picture size such a lens gives an angle of view of about 45° as you can seen in figure 1.2. (If the camera has a separate viewfinder this must of course have the same angle.)

A lens giving about 45–50° angle of view is traditionally considered normal for photography largely because it is the viewing angle we usually adopt when examining prints. A five-times enlargement from the whole negative seen from normal reading distance 25 cm (10 in) recreates conditions similar to viewing the actual subject. The perspective of the image appears 'normal'. This is always the case if you examine the picture from a distance about equal to camera lens focal length multiplied by the degree of enlargement. The 45–50° angle is pro-

duced when the camera lens has a focal length about the same as the diagonal of the negative (or transparency).

A pocket camera gives smaller negatives, so it needs a normal lens shorter in focal length, typically 25 mm. For the tiny 13 × 17 mm frame, this lens gives a 45° angle of view. Similarly, a 4 × 5 in (100 × 125 mm) sheet film camera uses a 150 mm lens as normal. So the whole system is scaled up or down according to camera size.

1.3 A larger camera needs a longer focal length lens to include the same amount of subject.

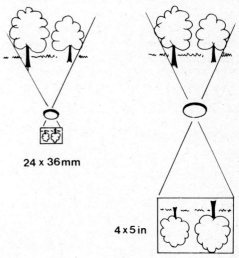

24 x 36mm

4 x 5 in

7

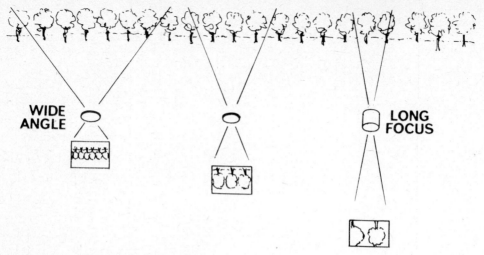

WIDE ANGLE

LONG FOCUS

1.4 Using the same camera but changing to a different focal length lens includes a greater or smaller amount of the subject.

Look at your friends' cameras. If anyone has a 6 × 7 cm rollfilm camera this is likely to have a lens of around 90 mm as normal; a 126 cartridge camera has one about 42 mm. When different cameras are lined up side by side they all take pictures which include more or less the same amount of subject. Each combination gives a similar angle of view.

If you can change the focal length of the lens on any particular camera, you can change the angle of view.

You can see the effect of changing lenses by looking through a home-made viewing tube. Figure 1.5 shows that the tube should be as long as the focal length of the lens, with a small peep-hole at the back and a frame the size of the camera's picture format at the front. (Use a cardboard colour slide mount.)

Wide angle lenses

If your camera is designed for interchangeable lenses the next most useful type to acquire is a wide angle. This is a shorter than normal focal length lens, e.g. a 28 mm lens for the 24 × 36 mm size camera. When you attach this lens to the camera body it takes up a position effectively 28 mm from the film. A scale drawing (figure 1.4, left) shows how the combination gives an angle of view much wider than a normal lens.

The wide angle lens includes more of the subject from the same camera position, by making all the details smaller. And it is ideal for getting more in when photographing interiors, or landscapes, or any subject where you could not move far enough back with a normal lens. Above all a wide

1.5 With a home-made viewing tube or an adjustable sight on a ruler you can discover the effects of different focal length lenses.

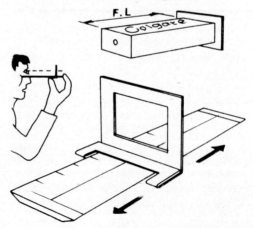

angle allows you to include subjects from a closer viewpoint, in order to get a picture with a steep perspective, i.e. with strong changes in size between things near and far. Look at figure 1.6.

Long focal length lenses

The long focus or 'telephoto' lens has a longer focal length than a normal lens (for example, a 135 mm lens covering a 24 × 36 mm format). It therefore includes much less of the subject. Figure 1.4 shows its narrow angle of view. The lens is bigger and sticks out further from the camera than normal or wide angle types.

A long focus lens forms a bigger image of the subject from the same camera position. It is useful for filling the picture when you have to be a long way away—for sports or wild-life subjects for example. Because you are so far away there is much less variation in scale between foreground and background parts of the picture. Perspective is flattened or 'cramped up' as you can see in figure 1.7. Long focus lenses exaggerate the image blurring effects of camera shake. Compare the way small movements of your long focus sighting tube causes the scene to appear to move about violently, whereas this is much less noticeable using the wide angle. So with a long focus lens choose a fast shutter speed or use a tripod.

For a 35 mm camera long lenses are made up to 1000 mm (3 ft 3 in) focal length. Wide-angle 'fish-eye' lenses of 8 mm focal length give over 180° angle of view. But as you can see from figure 1.1, the extreme type of image formed is so unlike human vision the lenses are difficult to use. Every picture is distorted by extremely flattened or extremely steepened perspective. Unless

1.6–8 How change of distance alters perspective. Taken with (top) 28 mm lens, camera 30 cms from near part of chessboard. (Centre) 135 mm lens, camera 145 cms from board, and (bottom) 50 mm lens, 54 cms from board.

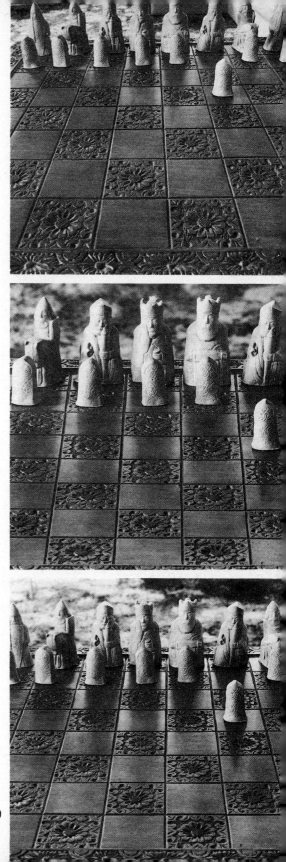

9

1.9–10 Left, steep perspective. Photographed from a close viewpoint, using a wide angle (28 mm) lens. Right, flattened perspective. Distant viewpoint, long focus (135 mm) lens.

you want a special effect or must work in very difficult conditions keep to the more useful, modest range of focal lengths such as 28 mm, 50 mm and 135 mm.

Fittings, viewfinders

Interchangeable lenses have either screw-in or bayonet fittings which couple to the camera body. With a bayonet coupling you just insert the lens and give a fraction of a turn. Screw-in lenses take longer to change, but the widest range of new and used lenses are of this type. Bayonet mounts are generally unique to particular cameras, so you may have to keep to one maker. Think carefully when you buy the basic camera. Will it allow you to build up a useful range of lenses at the right price? And if later you

want to change to a more elaborate body can you use your existing lenses?

With a single lens reflex camera, the picture produced by any lens you fit is displayed on the focusing screen. (The same applies to most sheet film cameras.) But a direct viewfinder camera needs viewfinder adjustment. Some have frame lines for each focal length shown in the viewfinder, figure 1.11. For others, you need a separate unit. A few twin lens reflex rollfilm cameras allow you to change lenses, in pairs.

As an alternative, you can add optical components to alter the focal length of a normal lens. The attachment *converts* it to a telephoto or wide-angle type. You can fit a convertor in front of a fixed lens. (In direct viewfinder cameras a second lens is needed to convert the viewfinder.)

They mostly produce poorer image quality than a separate, self-contained lens. You can fit a converter between an interchangeable lens and the camera body.

1.11 A direct vision finder marked for different focal length lenses. (Often frame corners only are shown).

Main features to remember

Compared to a normal camera lens, a *wide-angle* type allows you to get in more from the same position, or the same amount from a nearer position. It also gives greater depth of field than a normal lens set to the same *f* number (more about this overleaf). But a wide-angle lens must be designed for the job. If you try using a short focus normal lens as a wide angle for the next camera size up the picture will probably have unsharp or darkened corners.

A *long focus* lens enables you to get a larger image from the same position, or to include the same amount as a normal lens from a more distant position. It gives less depth of field at the same *f* number, and the lens is not designed for quite such close subject focusing. The widest aperture given by the long focus lens is smaller than most normal lenses, and because of its image magnification there is greater risk of camera or subject movement blur.

Controlling depth of field

Depth of field, which is the distance between nearest and furthest parts of the subject rendered sharp at one focus setting, is a very important factor in creating your picture. Shallow depth of field concentrates interest on just a few elements in a crowded scene—like an eye which has picked out only what it wants to examine. Much deeper depth of field can render detail sharply throughout space; the viewer of the photograph has more freedom to decide where he wants to look. Compare figure 1.14, which presents all the information, with figure 1.15 which uses depth of field to force your attention onto what the photographer

1.12 Depth of field changes with subject distance (see normal lens), and also with change of focal length.

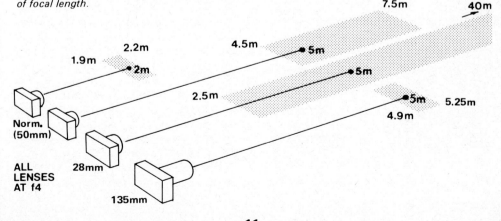

chose to pick out in focusing his lens.

You can master depth of field by remembering its three controlling factors—aperture, subject distance, and focal length. For *deep* depth use the lens stopped down to a small aperture. Don't approach closer than you need, figure 1.12 shows the increase in depth of field when your subject is further away. And remember that other factors being equal, a short focus lens gives greater depth of field. This is where small format cameras always have an advantage over larger types.

You can also help matters by making careful use of the depth of field indicator often found on the focusing ring of the camera, figure 1.13. For example, this shows that if you photograph a landscape with the lens focused on the horizon ('infinity') everything is sharp from infinity down to 10 m at ƒ8. But it will be better to focus on 10 m instead, because your depth of field then extends from infinity to 5 m (see *hyperfocal distance*, page 118).

For shallow depth of field all the opposite factors apply. You use widest lens aperture and if possible work closer to the subject. A larger format camera, because of its longer focal

1.14 Deep depth of field, Aperture f16, wide angle lens.

length lens, gives less depth of field, even at the same *ƒ*-number.

Pictures like figure 1.15, with shallow depth of field, are said to have differential focus. You will find it quite difficult to achieve differential focus within a distant subject—picking out one tree in a landscape for example—unless you change to a long focus lens and use it at widest aperture. On the other hand in close-up work differential focus becomes quite difficult to avoid. If stopping well down and perhaps changing to a short focus lens still gives insufficient depth of field you have to rearrange viewpoint so that the various parts of your subject are less varied in their distances.

One other technical factor affects depth of field. This is the standard of sharpness you demand from your negative or transparency. As figure 1.16 shows, on either side of true

1.13 Depth of field indicator on lens shows that at f8 focusing on 10 metres instead of infinity gives greatest depth of field.

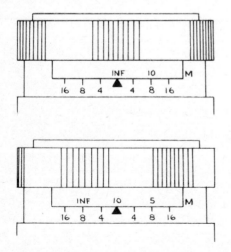

sharpness what should be a point is reproduced as a tiny circular patch of light. The circle becomes bigger the further you move from true pin-point sharpness, so that the image becomes less and less sharp. Most depth of field scales work on the basis that circles 0.025 mm or smaller are indistinguishable from a point. This works provided the negative is given only moderate enlargement, say 5 times. If you intend to make an unusually big print and examine it closely for fine detail you must expect less depth of field than the scale suggests. See 'circles of confusion' page 116.

1.15 Shallow depth of field ('differential focus'). Aperture f2, normal lens.

1.16 Out of focus point of background detail spreads into a circular patch of light. Stopping down reduces patch size, so background looks less unsharp.

Focusing close-ups

Extreme close-up photography offers all sorts of opportunities for interesting, creative pictures, particularly in colour. But first you must know how to form sharp images of nearby subjects. The rule is that the closer the subject, the further the lens must be focused forward away from the film. In figure 1.19 the subject was only 9 cm ($3\frac{1}{2}$ in) away, and the lens had to be focused out until 11.2 cm from the film to give a sharp image.

Your camera lens probably does not move sufficiently far forward in its mount to focus subjects closer than about 40–60 cm (1.5 ft). If the lens is

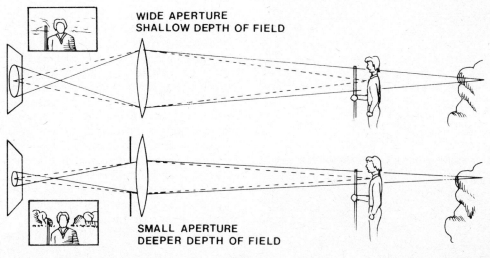

WIDE APERTURE
SHALLOW DEPTH OF FIELD

SMALL APERTURE
DEEPER DEPTH OF FIELD

13

removable you can attach bellows or extension rings to space out body from lens. Rings are cheapest but extend the lens forward by a set amount, which may not be quite the distance you need. The focusing mount of the lens itself allows you some further adjustment (marked focusing distances are of course no longer correct) and if you have several rings of different lengths you can usually combine them to make up the extension needed.

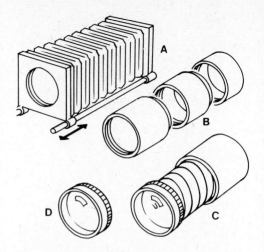

1.17–19 Top to bottom: Normal lens at closest subject focusing distance; with 1 cm extension ring added; with a 5 cm tube. (All at f2.)

1.20 Equipment for close-ups. A: Bellows unit. B: Extension rings or tubes, C: Macro lens. D: Close-up lens attachment.

Focusing bellows are easier to use because you can continuously vary the lens-to-film distance. However, the bellows take up too much room to allow the lens to focus distant subjects too. For full range focusing you really need a *macro lens*—a lens specially designed for close work and with an extended focusing movement ranging from infinity to about 125 mm (5 in).

Actual lens to film distances needed for various distances of subject are explained on page 121, but one or two are useful to remember. For example, to make an image exactly the same size as the subject you must have the lens twice its focal length from the film; and to form an image which is half the height of the subject the lens–film distance must be $1\frac{1}{2}$ focal lengths. So if you wanted to record a 50 mm (2 in) butterfly specimen 25 mm (1 in) on the film with a 50 mm lens you need an extension tube or bellows 25 mm long to fit between lens and camera body. If you change to a 28 mm lens an extension of only 14 mm is needed. So in close-up work, if your extension tubes will not allow a big enough image, use them instead with a shorter focal length lens.

If you camera lens is fixed, you can-

not fit extension tubes and will have to use a close-up lens attachment instead. This lens element fits over the front of your normal camera lens, like a filter. When the main lens is set to infinity, subjects at a distance equal to the focal length of the attachment will be sharply rendered. In fact you can work within a range of close-up subject distances by altering the focusing of the camera lens. Cameras with separate viewfinders—twin lens reflex or direct vision types—need an additional lens over the finder to compensate for sighting differences when working so close up. (Causes extreme parallax error.) If you do a lot of close-up work all at the same image magnification, a home-made gadget such as a positioning frame will be helpful. Project 1.5 gives details.

Remember that the greater the magnification of your subject, the less depth of field your picture will have—compare figures 1.17 and 1.19. You will probably need to use the lens stopped well down. Also exposure time will need a special increase if you use bellows or extension tubes, but have a separate meter to measure the light. Page 121 again gives details. This correction is not needed for a close-up lens, and is automatically calculated if you measure with a through-the-lens meter.

Basic camera movements

Apart from focusing, other movements of the lens and camera give important image controls. For example, you have probably taken pictures like figure 1.21. The parallel sides of the buildings appear to converge upwards because the camera was tilted to get the top of the building in. Some special single lens reflex camera lenses are made with a *shift movement*—a control to shift the whole lens several millimetres upwards, downwards or sideways. On the focusing screen you can see the image move quite considerably in

1.21–22 Pointing the camera upwards makes vertical lines appear to converge. Keep the camera back vertical, then use a shift lens or change to wide angle lens and enlarge only the top half of your negative.

these directions. So for the building picture you hold the camera with its back quite vertical, which makes the building sides appear parallel but cuts off the top and includes more foreground than you need. Shifting the lens upwards makes the image move downwards until the whole building is included, this time with parallel sides.

Large sheet film cameras allow you the greatest range of movements

1.23 *Left: shift lens fitted to a 35 mm camera. Right: large format sheet film cameras allow a whole range of 'movements'.*

(figure 1.23). They include lens shift in directions giving *rising front*, *drop front* or *cross front*. Also independent swing and tilt pivoting of the front and back of the camera, which allow you to make best use of depth of field. Swings work this way. Suppose you are photographing a long wall obliquely. Swing both camera back and front as shown in figure 1.24 until the subject, lens panel and film plane are all slanted towards one imaginary point. The wall is now sharply imaged throughout, often without stopping the lens down. This is known as the Scheimpflug Rule and is worth remembering. You can also use tilting front and back like figure 1.23 (right) to produce extra rising front effects.

Lens quality and care

A good camera lens contains several specially designed, shaped and accurately spaced glass elements. So don't drop it, and never buy a used lens which is dented. Each glass surface is given a transparent anti-reflective coating—usually of metallic fluorides—to reduce light scatter or 'flare'. This would otherwise dilute the dark parts of the image, reducing its con-

trast and brilliance. Scratches, dust, greasy finger marks or condensation on the lens surface reintroduce flare and spoil image sharpness. Use a lens cap, or ultraviolet (clear) filter, or at least a case to protect the lens when not in use. Dust can be carefully removed with a blower brush, and the glass gently wiped with a lens cleaning cloth. Protect the lens from rain droplets too—they should not be allowed to dry out and leave marks on the

1.24 *Swinging the front and back of a technical camera to improve depth of field, see text.*

glass coating. If condensation appears on the lens give the glass time to warm up before use.

PROJECTS

P1.1 Make long focus and wide angle pinhole cameras. Use a 1 metre long cardboard tube for one and a pillbox about 30 mm deep for the other. Paint each matt black inside. Ideally the holes, made in kitchen foil, should have diameters 1 mm and 0.1 mm respectively. Expose onto film or bromide paper (ASA 2), giving 500 times the meter reading for $f\,8$.

P1.2 Check the image coverage given by a normal lens. Use the 50 mm lens taken from a small format camera to take a picture of a distant subject in a 5×4 in camera. Examine the negative carefully with a magnifying glass. Would your lens give a satisfactory image over a 6×6 cm picture format?

P1.3 Take pictures of a scene having foreground, mid-ground and background, using (1) a wide angle lens and (2) a long focus lens from exactly the same camera position. Enlarge the centre of (1) until it includes the same area as (2). Compare perspective, depth of field, image quality and grain.

P1.4 How big a close-up can you photograph? Combine a short focus lens with as many extension tubes, bellows etc as you can fit together. Focus by slowly moving the whole camera towards or away from the subject. Work out your exposure.

P1.5 Construct a close-up focusing bracket like the one shown above. Set up the empty camera at a subject distance chosen to suit a particular close-up lens or extension ring. Hold the shutter open on 'B' and use tracing paper across the back of the camera to check the area of subject included. Make up and attach an L frame in wood or wire which just avoids appearing in the picture. Now try taking close-ups without focusing or using the viewfinder.

1.25 Home-made close-up bracket, see Project 1.5.

QUESTIONS

Q1.1 How does the use of wide angle and telephoto lenses enable the photographer to extend the scope of his work? Compare the results with those of a camera equipped only with a normal lens.

Q1.2 Draw diagrams and include brief explanatory notes to illustrate how depth of field varies with lens aperture.

Q1.3 Which of the following factors *increase* depth of field? Shorter focal length lens; more distant subject; wider aperture; using a tripod.

2. Control of Lighting

Light is the basic ingredient of photography. It allows us to make images. Its character affects the appearance of our subjects. For lighting is not just a matter of brightness, but direction and quality too. Train yourself to observe everyday lighting situations, indoors and outdoors. Look at the way other people use it, in advertising photographs for example. The best way to learn to use lighting creatively is to organise yourself a 'studio'—a blacked out room of reasonable size. Have two or three lights on adjustable stands, a still life subject, and a camera on a tripod. You do not need special lights—simple bulb-holders, reflector bulbs and adjustable angle table lamps can all be called into service.

Basics of lighting

The type of lighting effect you get depends upon the quality, direction, colour, and intensity of your light source. Consider these one at a time. *Lighting quality*. This is the term used to describe whether the light is harsh and hard (like direct sunshine on a clear day), or diffused and soft (like overcast daylight). In other words, it is concerned with the type of shadows formed. A hard, contrasty light source creates distinct, sharp-edged shadows like figure 2.1. The lamp itself needs to be relatively small and compact— all the light rays come from one point and so can be completely 'blocked off' by parts of the subject, forming dense black shadows. Hard lighting is good for exaggerating texture and dramatising form, particularly when used obliquely; but it can give you problems, too, if contrast is too extreme for the film to record detail in shadows and highlights at one exposure. Light

2.1–3 Quality of light affects texture and detail. Top: Lit by spotlight. Centre: Small flood. Bottom: Flood diffused with tracing paper. Harsh lighting gives rich colour.

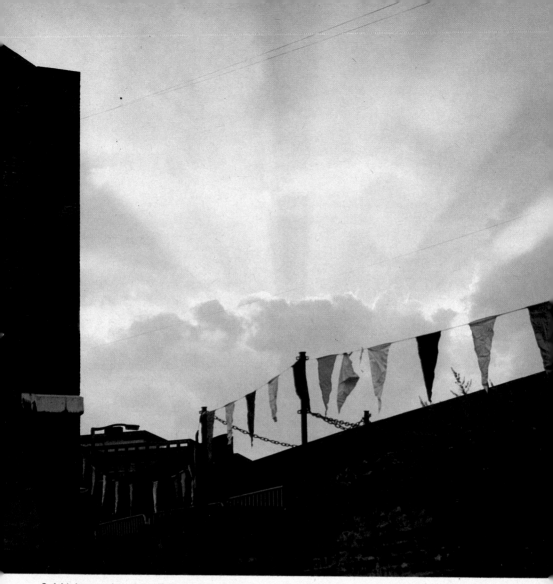

2.4 Light travels in straight lines. Sometimes the rays themselves form a main element in the picture.

sources which give you hard quality include clear sunlight, spotlights, flash-bulbs, small electronic flashes, clear glass bulbs, even a candle flame.

Soft and diffused lighting produces gentle, graduated shadows. To do this the light source must be relatively large. Light then strikes the subject from so many different directions hardly any part of subject or background fails to receive some illumination. Soft lighting is excellent for sub-jects containing many shapes and tex-tures, which would look too compli-cated with hard shadow lines. In the studio you can use a floodlamp with a large matt white reflector and pearl glass bulb (figure 2.2) to give fairly soft quality illumination. This can be further softened by directing the light through diffusing material such as a large sheet of tracing paper. In fact any hard light source can be softened either by a diffuser, or by reflecting it

19

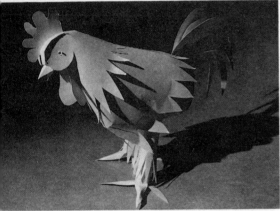
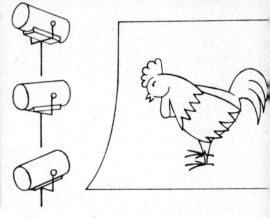

2.5–8 The effect of changing the height of the light source.

off a large matt white surface, preferably close to the subject. The same thing happens on a bigger scale when sunlight is diffused by totally overcast cloud conditions—rather like tracing paper drawn across the sky. This can give virtually shadowless lighting.

The size and surface of the reflector

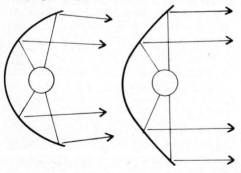

2.9 Polished reflector shapes. The deep elliptical one, left, concentrates light. The parabolic shape gives a parallel beam.

behind your lamp or flash source also affects the quality of the light. Small, shiny reflectors help to give hard lighting and large matt textured or white painted types diffuse the light.

Height and direction. The direction from which light reaches it transforms the appearance of a subject, changing its shape and form. Figures 2.10–13 show what happens when you change lamp position in an arc around a still-life subject, keeping it to the same height. In figures 2.5–8 the lamp remained on the same part of the floor, and was this time varied in height. Notice how each new lighting direction emphasises a different part of the sculpture. Some areas are merged together, others strongly separated. The structure can be made to look flattened or rounded; and notice how a change of background tone affects its shape and outline. A hard light

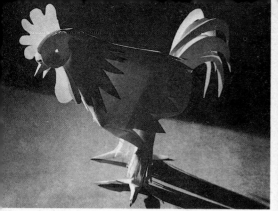

2.10–13 The effect of changing lighting direction (the spotlight remained the same height).

source was used for all these pictures. Softer light has a less dramatic and contrasty effect.

Brightness and evenness. Many people think that bright lighting is essential for photography, but with modern lenses and fast film this is no longer true. If you can see a subject you can also photograph it; because however dim the lighting, exposing for long enough will record a result. (Of course, if you also need a short shutter speed to freeze movement dim light will create problems. Flash might therefore be the answer provided its quality and direction suit the subject and mood of your picture.)

Unevenness of lighting cannot be corrected by adjusting the exposure. Its effects always seem to be exaggerated by photography and often you have to give complicated shading when printing. Some lighting equip-

ment allows the light source to be moved within the reflector to give a more even spread of illumination. You may even be able to change to a different reflector shape (figure 2.9) which gives a more useful distribution of light. Alternatively you can redirect some light back to the underlit areas

2.14 To improve evenness move your lamp further away. Distances to nearest and furthest parts of the surface are then more similar.

with a large reflector board or use a second lamp. Often the best cure is to change to more diffused lighting, or just move the light source further away, see fig 2.14.

Lighting colour. Each so-called 'white' light source—studio lamps, daylight, flash etc—gives a slightly different mixture of coloured wavelengths (see 'colour temperature', page 47). For example, studio lamps produce slightly more orange and less blue light than daylight. Our eyes can accept either as white. These variations can generally be ignored in black and white photography but become most important in colour work (chapter 4) because colour films are designed to give accurate results with light of a particular colour balance. So unless you want specially warm or cold colours to give atmosphere to your picture keep to the intended light source. Similarly try not to use lamps of the wrong voltage—this makes the colour too orange or blue. If necessary use a colour correcting filter over the lens or the lamp, see page 50.

Finally remember that only the brightness and overall colour of the lighting can be compensated for by exposure or filtering techniques. You can never alter hard shadows into diffused shadows, or frontal lighting into side lighting by some trick of camerawork, processing or printing.

Lighting equipment

Photographic lighting equipment is of two main kinds—spotlights and floodlights which require a mains electricity supply, and electronic or bulb flash which works mostly off batteries.

2.15 Using daylight plus (left) a white card reflector and (right) a floodlamp which gives warm colour on daylight film.

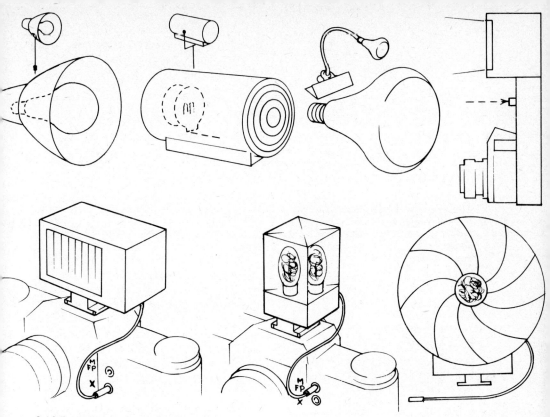

2.16 Top: Floodlight, focusing spotlight, integral spot lamp, large electronic flash with sensor. Bottom: Electronic flash, flashcube, and flashbulb gun.

A *floodlight* has a diffused glass light bulb surrounded by a large reflector. It therefore gives fairly soft, even lighting. The lamp itself may be a 'studio' tungsten or tungsten halogen type, often 500 watt, which runs for about 100 or more hours; or a 'photoflood' lamp. Photofloods are fairly cheap and produce a great deal of light (and heat) but run for only 3 or 10 hours according to size. They also give slightly bluer light than ordinary studio lamps (see page 47).

A *spotlight* uses a small, clear glass lamp usually enclosed in a lamp house with a moulded lens unit at one end. A lever moves the lamp forwards or backwards, to give you either a broad or a narrow beam of light. Spotlighting is harsh—sharpest shadows are given at the broad beam setting.

Both flood and spotlight heads are best mounted on floor stands which allow you plenty of adjustment of height and tilt. Some photofloods have reflectors forming part of the lamp unit itself (figure 2.16) and so only need a simple bulbholder.

Electronic flash also shown in figure 2.16, is a device which gives a bright pulse of light each time electricity is passed through a small gas-filled tube. The flash is triggered by connections inside the camera as soon as the shutter is fully open (known as 'X' synchronisation). The flashgun is therefore usually mounted in a connecting shoe on the camera body or at least must be attached to it by a shutter synchronising lead. Power for the flash comes from its internal batteries (which may be expendable or rechargeable), or from a mains adapter. Large studio flash units work only off the household electricity supply.

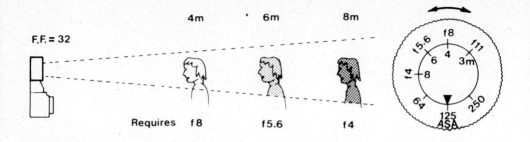

F.F. = 32 4m 6m 8m

Requires f8 f5.6 f4

2.17–21 Using a flashgun having a 'flash factor' of 32. This would be shown on the unit's calculator dial. Below: Most focal plane shutters when used faster than 1/60 sec record only part of the flash picture.

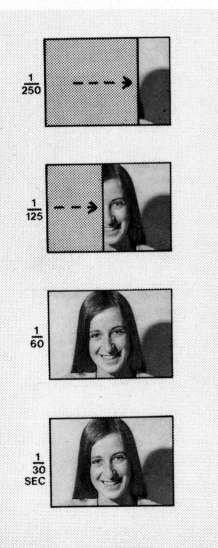

Flashbulbs are much simpler. Everything happens in a tiny blue glass bulb filled with inflammable wire. When you connect a weak electric current to its contact pins a miniature fuse inside the bulb ignites the wire, which burns out in a brilliant flash of light. The power comes from a battery or similar device in the flashgun or the camera. Ideally, the circuit is triggered by the camera shutter about 1/60 sec (17 millisec) before it is fully open. This 'M' synchronisation allows the bulb the necessary time to reach full brilliance. Each flashbulb can be used only once only—and has to be changed after each picture. The job is made faster by having four bulbs at a time mounted in a 'flash cube'. You (or the camera) just rotate the cube 90° between exposures.

A bulb flashgun is simple and cheap, but you must buy a bulb for each and every exposure. Electronic flash equipment is more expensive to buy, but it gives you thousands of flashes. The light from both blue bulbs and electronic flash are more-or-less equivalent in colour to daylight. As for lighting quality, the small size of the bulb or tube and the effect of its polished reflector mean that most flashguns give very hard light, but this can be softened by diffusion, page 29, just like any other light source.

Of course the biggest difference between flash and any other form of lighting is its brief duration—typically 1/50 sec (bulbs) and 1/500–1/10,000 sec

(electronic) according to design. This is an advantage for freezing movement but makes judging the exact effect of your lighting and exposure measurement rather difficult. You have to guess the best height and direction, based on your experience of using studio lamps. See pages 20–21.

Moreover, you cannot use an ordinary exposure meter to measure the flash. Instead the flashgun manufacturer gives you a 'flash factor' or 'guide number' for use with each type of film. This number is the flash-to-subject distance multiplied by the lens f number required. So if the factor for your film and flashgun is 32 (metre distances) this means $f8$ at 4 metres (13 ft), or $f16$ at 2 metres ($6\frac{1}{2}$ ft) and so on. The required f numbers are often worked out for you on a dial on the flashgun, figure 2.17.

Many electronic flashguns now have a small light-sensing device which points towards your subject from just below the flash-head. You set the film speed on a dial of ASA numbers. From that you read off the f number to set on your lens (some flashguns have several settings). Each time you take a picture this device measures the light reflected from the subject and instantaneously cuts off the flash when enough light has been received. So you get a very brief flash when working close-up, and a longer one when further away.

Another method of measuring exposure is to use a special flash exposure meter. You hold this meter at the subject pointing towards the camera; then fire one flash (using the flashgun test button), and the needle 'sticks' on the f number needed.

Notice how exposure for flash is really only concerned with lens aperture. The flash itself provides the exposure time and the camera shutter just opens and closes before and afterwards to prevent much other light recording. Most focal plane shutters fitted to

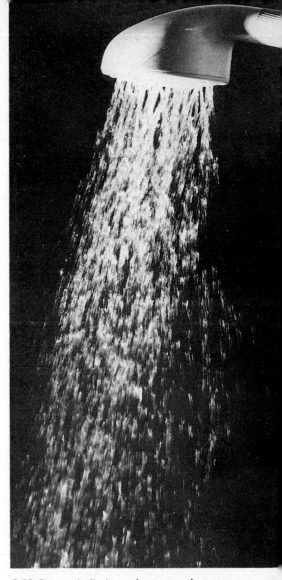

2.22 Electronic flash can freeze very fast moving action. Lit by self-regulating flash 1 metre away from the spray.

single lens reflex cameras are marked for flash at the 1/60 or 1/125 sec speed setting. This is because at 1/60 sec or any slower speed the whole picture area is uncovered simultaneously. (At faster speeds the shutter blind exposes by passing a *slit* across the film—you don't get a complete picture when this is frozen by the flash, figures 2.18–21.)

On some models, the situation is complicated because the synchronisation (X or M) is coupled directly to

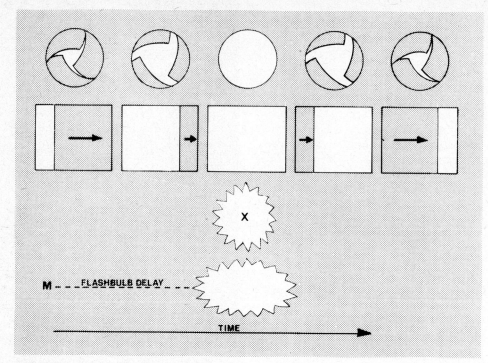

2.23 The opening, exposing and closing action of a bladed shutter and a focal plane shutter, at 1/60 sec. Electronic flash (X socket) is triggered when shutter is fully open, because it fires instantaneously. Bulb flash (M or FP socket) is triggered earlier, allowing it time to reach full power.

2.24 Lighting attachments, Diffuser (A). Filter holder (B). Snoot (C), and Barndoor (D). Similar types attach to floods. Reflector board (E) clips to flash head tilted vertically.

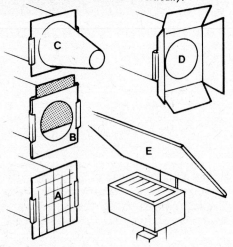

the shutter speed dial. Check the instructions for any unfamiliar camera.

If your camera has a bladed shutter within the lens this will synchronise with flash throughout its full range of speeds provided the gun is connected correctly to either X or M synchronisation sockets. Some light from a flashbulb may be 'clipped' if you use the shutter at speeds faster than 1/125 sec. Small flashbulbs synchronise with a focal plane shutter on 1/60 or 1/125 sec if the camera has an M (or FP) socket. If you fire bulbs on X, you must allow time for them to ignite by using a slower speed, e.g. 1/30 or 1/60 sec. If all this sounds a bit complicated figure 2.23 summarises the most important technical points.

Accessories. You can buy or make various attachments for your lighting equipment. Most of the useful ones are shown in figure 2.24. Snoots and barndoors narrow the light beam from spotlights. They also help to prevent light flare into the lens (which can

easily spoil image contrast and detail when the lamp is pointed from behind the subject). Diffusers and reflector boards improve evenness and soften the lighting quality from spots, floods or flash. Sheets of tinted acetate colour the light for special effects, or will convert studio lights to the same colour as daylight. NB. Electric lamps get very hot, so make sure any home-made lighting units or attachments allow for ventilation, and do not distort with heat or catch fire.

Using lighting

One light source. We are all used to seeing the world lit by one light source—the sun. Notice (below) what changes occur throughout the day as the sun alters in height and direction. You can see how the hard light gradu-ally picks out different parts of the building, emphasising textures across different planes, and separating or merging elements in the landscape. Often the most interesting lighting occurs early or late in the day, rather than around noon when the sun is overhead.

Try to use your lighting to suit the mood and qualities existing in the subject. Sometimes light itself forms a main part of the picture. In figure 2.4 it adds a great radiant motif to the drab flags. In figure 2.22 the strong, oblique backlighting emphasises the sparkle and texture of water.

If you are using natural lighting and a static subject you will have to wait for the time of day and weather conditions which give the right *direction* and *quality* of light. For subjects such as portraits, you can position the figure

2.25–8 Changes in sunlight direction—Morning, noon, afternoon, evening. Notice how lighting colour changes too.

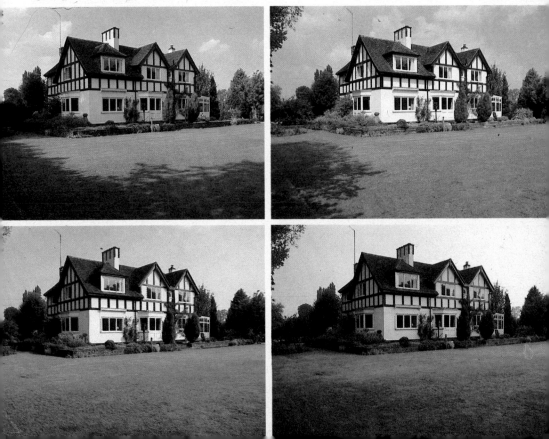

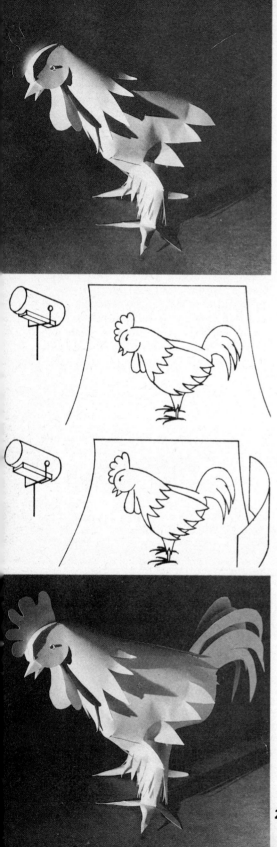

2.29–30 *Spotlight used alone and (bottom) with a large white card added on the right. Shadows become lighter, without extra shadow lines forming.*

to receive light from the best direction to give the shapes and textures required. If you want soft lighting on a day with harsh sunshine take your picture within the shadow of a building or trees. (NB. On colour film light from a blue sky like this gives you a bluish image.)

Working in the studio of course you have greatest lighting freedom. However, unless you want theatrical effects keep to one predominant light source, and position it somewhere above camera height. This approximates daylight conditions and so gives a fairly natural looking appearance. Despite this there are no fixed rules to lighting direction, so experiment.

Be careful about contrast. Outdoors in daylight the sky always gives some illumination to shadows; but in an otherwise darkened studio, direct light from a single lamp can leave very black shadows indeed. So you may want to 'fill in' shadows with just enough illumination to record a little detail. Try using a white reflector as shown in figure 2.30. This throws back very diffused light and so does not produce a second set of shadows. Another approach is to form softer shadows by placing a diffuser in front of the light source, or by turning the lamp away and 'bouncing' its light from a large white surface such as ceiling or wall.

Although we talk of lamps, exactly the same lighting can be achieved with flash. The usual mounting for a flash-gun is on the camera itself. This saves you the bother of holding it separately, but is just about the crudest, least interesting direction from which to light

2.31–33 *Right: Using a single flash gun (top) bounced from wall and ceiling, (centre) held at 45°, (bottom) pointed direct from camera.*

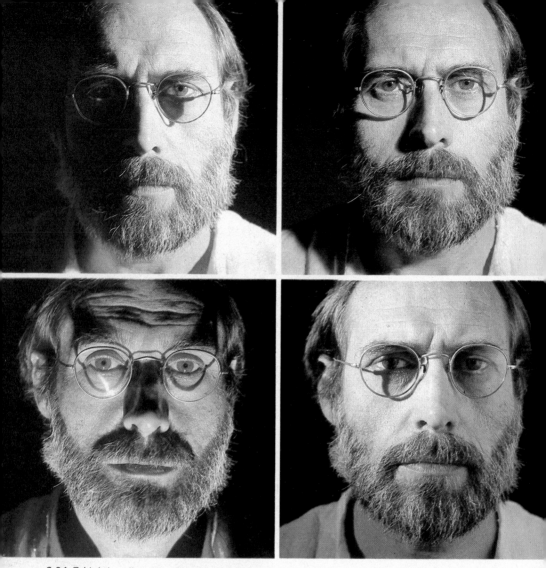

2.34–7 Lighting direction alters appearance of face shape and features. (Top pair) One lamp used from side; and top frontal. (Bottom) Lit from below; and side plus reflector.

a subject. Try taking the flash *off the camera* (make or buy an extended synchronising lead) and use the flash-gun from various heights and directions, diffused or bounced, just like a lamp. You may need someone to hold it for you, or use it attached to a chair or tripod. If you use flash factors for working out exposure open the lens one stop using a diffuser, or two stops for bounced flash.

Two or more lights. Having several lamps gives you more scope for lighting, provided you think about what each one should do. Choose one to be your main or 'key' light—the one casting the predominant shadows. The second lamp might be used bounced or diffused from near the camera to help lighten these shadows and therefore control contrast. A third lamp can

2.38–40 Right: Using one, two, and three lamps. Every light has a separate function. The result has only one set of shadows.

30

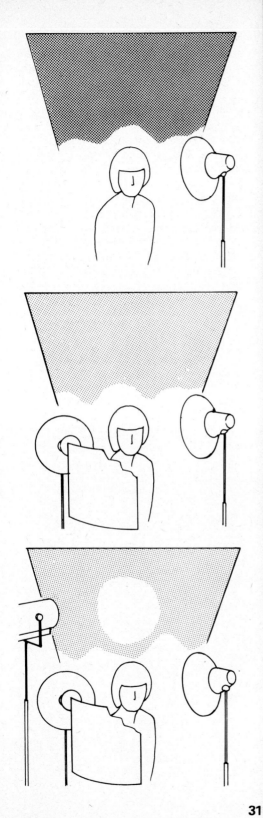

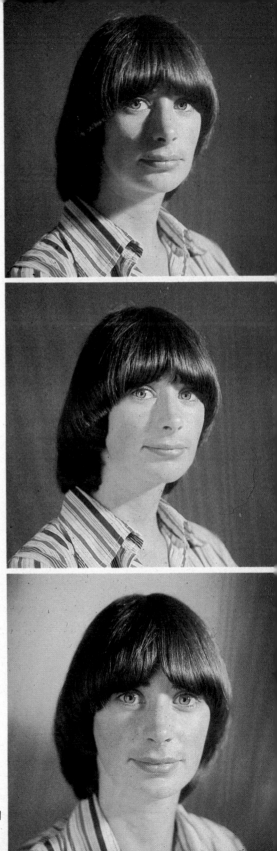

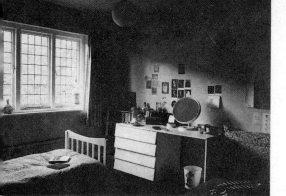

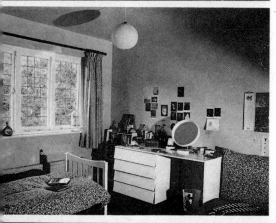

illuminate the background to give just the right tone to separate it from the subject and give the picture depth. Figures 2.38–40 show how lighting can be built up carefully this way—not just pointed from all directions to give bright illumination. Always try using as few lamps as possible and keep your lighting arrangement simple. If you are using several flashguns in this way judge your exposure for the key light flash alone. Studio lighting is discussed in more detail in chapter 7.

Mixed lighting. Lamps are useful to improve lighting conditions in room interiors (measure the unevenness with an exposure meter, reading at both ends of the room). If you use a lamp or flash to make this existing light

2.41–3 Controlling contrast. Top, daylight alone gives uneven lighting, $\frac{1}{4}$ sec f16. Centre, firing a flash (factor 40) from the right, two metres from room centre helps, but gives unnatural effect. Bottom, flash (at double power) bounced off wall, right, gently fills-in without giving shadows.

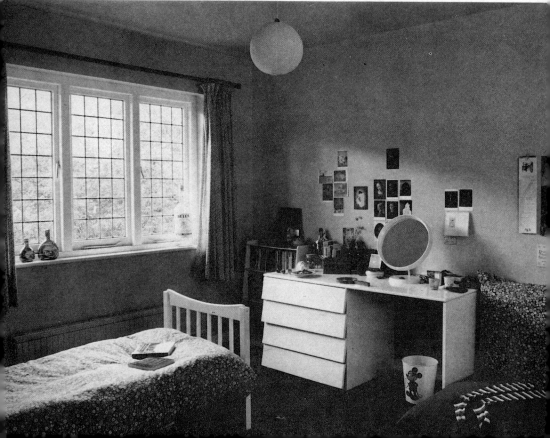

more even take care not to introduce shadows or patches, figure 2.42. Reflect the illumination off a wall or part of the ceiling not included in the picture. You may have to control its brightness with diffusing material so that the room still seems to be lit naturally from the windows, figure 2.43. A sheet of blue acetate filter over the lamp will match its colour to daylight if you are using colour film.

PROJECTS

P2.1 Find several published examples of creative photography using (a) hard lighting and (b) soft lighting. Include pictures taken outdoors as well as in the studio. Can you find examples of paintings which also strongly use qualities (a) or (b)?

P2.2 Take a series of head and shoulders portrait outdoors. First arrange that direct sun reaches the sitter's face from above and behind the camera. Then move the camera and turn the sitter until the sun is directed 45° to the face. For the third picture have the sun sidelighting from 90°. Now repeat the last two shots holding a 20 × 16 in white paper reflector about 18 in from the shadow side of the head. Process, print and compare results.

P2.3 Take a head and shoulders portrait in the studio using a single light source and a white reflector board. Make your lighting look as natural as possible.

P2.4 Subjects lit from below always look strange or unnatural. Floodlit buildings, a room illuminated by sunlight reflected off snow, or an actor lit by footlights, are all examples. Find a suitable sitter and make a portrait which is as eerie as possible, without being unrecognisable.

P2.5 Set up a simple still-life subject containing both vertical and horizontal surfaces. Using a single floodlight take seven pictures—four in which the lamp is used from quite different direc-

tions and three which vary only in lamp height. Try to make each picture as interesting and different as possible.

P2.6 Set up, light and photograph a silhouette image. This should include a figure in profile, plus appropriate objects, cut out shapes etc, to suggest surroundings. Print onto hard grade paper.

P2.7 Check your camera shutter synchronisation. Open the back of the empty camera and look through it, pointing the lens and your electronic flash gun directly toward a light coloured surface. Plug the flash into the X socket and open the lens to widest aperture. When the flash fires you should see its light across the whole picture area. But plugged into the M (or FP) socket electronic flash cannot be seen through the camera. Why is this?

P2.8 Take a group portrait of two or three people, using a flash from the following directions. (a) mounted on the camera (b) at arms length from the camera, above and about 45° to the subject (c) reflected off the ceiling and a wall to one side of the subject. Remember to open the lens an extra two stops for (c).

P2.9 Using the same subject as project 2.8, take three pictures using a spotlight from about 45° (a) direct (b) diffused with tracing paper (c) turned around and reflected off the ceiling and wall. Compare your results with the flash versions.

QUESTIONS

Q2.1 Is it true to say that bright lighting is always very 'hard' and a dim lighting always 'soft'? Explain the reasons for your answer and state what these terms mean.

Q2.2 Under what circumstances would it be an advantage to use flash for black and white photography? Outline differences between electronic and flash-bulb technique, discussing the advantages of each.

3. Film, Filters, Development

This chapter goes a stage further in explaining how black and white films and developers work, how they differ, and which to choose for the sort of image you need. Begin by actually looking and handling a light sensitive emulsion—say a piece of printing paper removed from its box in the darkroom, or the end of a film protruding from its cassette. The creamy or greenish grey coating consists of millions of grains of silver halides, set in a thin layer of gelatin. Touch the emulsion with a droplet of developer and you can watch the halides darken to black metallic silver.

You can even make a crude emulsion with halides such as silver bromide, silver chloride or silver iodide crystals in gelatin solution, page 42.

Types of black and white film

Films differ in their speed, colour sensitivity and contrast, and of course size. A 'fast' film (e.g. with an ASA rating of about 400 or above) has an emulsion which contains larger and more light-sensitive crystals. The pattern of black silver grains they form when processed is coarser and more noticeable when enlarged than in a slow film. The rule is, *the faster the film the more grainy the negative.* If you want really fine grain, choose a film of about ASA 50 or less.

For a very coarse grain image like figure 3.2 use a film of ASA 1000 or above, perhaps overdeveloped ('pushed', page 38) and enlarged onto hard grade paper. Most ultra fast films also have a thicker emulsion, and this, plus the graininess, means that they are unable to resolve fine detail. The most useful general purpose films are around 125–400 ASA, because they have good resolving power but enough sensitivity for most light conditions.

Films for general photography are all of medium or low contrast. You can also buy high contrast 'line' (or 'lith') film, mostly in sheet film sizes. This film when processed in a high contrast developer gives negatives in solid black and clear white, with few if any grey tones in between. It is excellent for copying drawings, written text, etc, or for converting normal photographs into line images like figure 8.32. All high contrast films are

3.1 High contrast line or lith film is ideal for copying a drawing or engraving like this.

3.2 Fast 1250 ASA film, over-developed to give 3000 ASA, allows action pictures in dim light (1/250 sec f2.8). Note coarse grain.

also very slow—about ASA 5-20.

Colour sensitivity. All the popular, general purpose black and white films are panchromatic (pan). This means that the emulsion responds to all the colours of the spectrum and records their brightness more or less accurately in tones of grey. Compare the top with the bottom of figure 3.3. In fact reds and blues reproduce a little lighter than they appear to the eye, and yellow–green slightly darker. A few films which are not intended to record coloured images are sensitive only to blue and green (orthochromatic) or just blue alone ('ordinary' or blue sensitive). These are also shown in figure 3.3. The advantage of materials of this kind is that you can handle and process them under quite bright safelights—deep red for ortho, and orange for ordinary materials, see figure 3.5. (Most papers for enlarging have 'ordinary' colour sensitivity.)

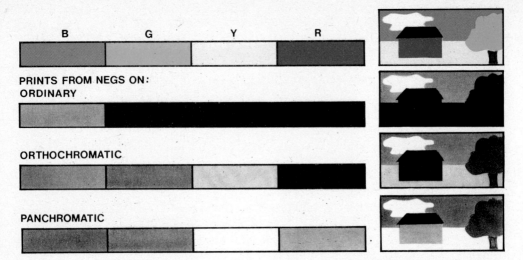

PRINTS FROM NEGS ON:
ORDINARY

ORTHOCHROMATIC

PANCHROMATIC

3.3 Above: How film colour sensitivity affects the black and white recording of colours.
3.4 Left: Colour filters. Subject colours stopped by the filter record darker. Colours passed appear lighter.

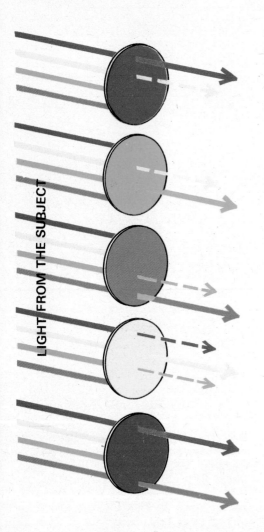

LIGHT FROM THE SUBJECT

Filters

Another reason for using panchromatic films is that it allows you some control over the black and white reproduction of colours, by means of colour filters. Figures 3.4 and 3.6 show how this works. Placing a filter over the camera lens *lightens* the appearance of objects the same colour as the filter, and *darkens* other colours, particulary those most remote from it in the colour spectrum. Colour filters do not affect the reproduction of greys, white or black (although they do sometimes reduce overall contrast). Weak filters have only a mild effect—a typical yellow filter for example will slightly darken a blue sky so that clouds stand out more distinctly. For more dramatic effects like figure 3.7 try really deep filter colours. You can always preview what changes will occur by looking at the subject through the filter first.

All colour filters, particularly the deep colours, absorb light. So, you need extra exposure. Often the amount by which you must multiply non-filtered exposure is marked on the filter mount ×2, ×6 etc.

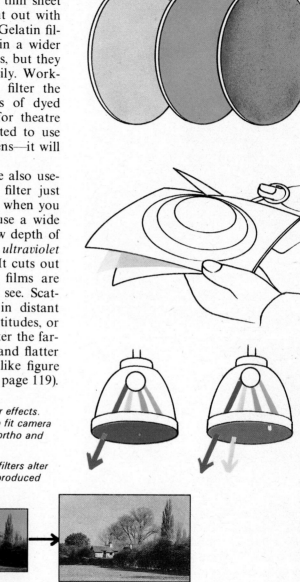

The actual filters you buy may be high quality dyed glass or a thin sheet of coloured gelatin to be cut out with scissors to fit over the lens. Gelatin filters are cheaper and come in a wider colour range than glass types, but they scratch and finger mark easily. Working in the studio you can filter the lamps instead, using sheets of dyed acetate like the type used for theatre lighting. But don't be tempted to use this crude acetate over the lens—it will upset image sharpness.

Two uncoloured filters are also useful. A grey, *neutral density* filter just cuts down the light—helpful when you have fast film but need to use a wide lens aperture (e.g. for shallow depth of field) on a bright day. An *ultraviolet* filter looks like clear glass. It cuts out UV radiation to which all films are sensitive but the eye cannot see. Scattered UV is often present in distant views, particularly at high altitudes, or near the sea. Without the filter the farthest detail records weaker and flatter than it appears to the eye, like figure 6.3. (See also polarising filter, page 119).

3.5 Top: Weaker filters give milder effects. Centre: shaping a gelatine filter to fit camera lens. Bottom: Safelight filters for ortho and ordinary materials.

3.6 (Below) How red and green filters alter the image received and finally reproduced using pan black and white film.

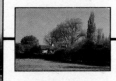

IMAGE SEEN

FINAL RESULTS

BY FILM

IN B&W

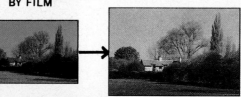

3.7 A deep red filter turns a deep blue sky almost black. It also darkens greens.

which the subject's darkest important shadow detail is just recorded. Avoid overexposure because delicate highlight tone values (e.g. important skin tones in portraits) become clogged up and will only print as white or a flat, featureless grey. Overexposure also scatters light slightly within the emulsion, increasing grain and reducing sharpness. When it comes to printing, bromide papers are designed to suit negatives given minimum correct exposure.

One way of compensating for exposure errors is to alter development. You can 'uprate' most films to, say, twice their normal ASA rating (which really means underexposing one stop) then 'push' or extend the time in the developer. But just remember what is happening—the overdevelopment is increasing *contrast* and *grain* as well as density. If your subject and lighting were very flat this extra contrast could be helpful, but if the image was contrasty to start with, like figure 3.9, you could end up with an unprintably hard negative. So there is always more scope for uprating (in fact for errors in exposure generally) when shooting

Exposure and development

Most people get muddled over the effects of exposure and development. You have to learn to check the *tone values* of the negative, and note how the darkest and lightest important details in the subject have recorded. For example, if the subject mid-tones and highlights appear in shades of grey but the shadows have vanished into clear film the cause is probably underexposure. If some detail can be seen in both shadows and highlights but the general appearance is weak and flat, the film is likely to be underdeveloped.

An overexposed negative has excellent shadow detail but mid-tones and highlights have merged into almost featureless black. Overdevelopment also gives a dark negative but mostly because it is very contrasty—highlights are very black and the negative looks 'bright'.

If you can, expose for a negative in

B & W FILM SPEEDS
(NORMAL DEVELOPMENT)

	ASA	DIN
Recording Film	1250	32
Tri-X/HP5	400	27
Plus-X/FP4	125	22
Verichrome Pan	125	22
Pan-X	32	16
Ilford Line Film	10	12
Kodalith Film	6	11

3.8

3.9 Right: A good negative of a contrasty subject. Detail is just recorded in wanted highlights (window view and bed top) and shadows (near side of bed and curtains). Black carpet and white paintwork can be ignored. Negative has a good tone range.

a low contrast subject. See exposure latitude, page 117. As a general guide aim for a negative which looks full of detail, but is much less contrasty than a print.

The developer. Buying a developer usually means buying a packet of powdered chemical or a bottle of solution. In fact, as table 3.10 shows, a general purpose negative developer like D76 contains four or five different chemicals, each of which has a particular job to do.

Developing agents play the main role in turning light affected silver halides—the invisible or 'latent' image formed by exposure—into a black metallic silver negative. (Not unlike black you find left on a cloth after polishing silverware.) The gentle working developing agent *metol* gives low contrast results, and contributes most to midtones and shadows. So it is usually combined with another developing agent, *hydroquinone*, which is more contrasty and helps to build up the blacker tones representing subject highlights. The *preservative* chemical prevents the developer from weakening too rapidly due to oxygen in the solution or surrounding air. And the *accelerator* makes the solution alkaline, essential to give a reasonably short developing time. Some developers also contain a *restrainer*, such as potassium bromide, to reduce chemical fog, page 118.

Some developers are designed to give maximum speed, others finest possible grain and resolution. See table 3.10. High contrast line developers often use hydroquinone only as developing agent, in a strongly alkaline solution.

MQ (Metol/Quinone) fine grain negative developers like D76 can be used

Chemicals	D.76 (Gen. F.G.)	D.23 (Cheap F.G.)	D.8 (Line)	Function
Metol	2	8		Developing Agent
Hydroquinone	5		23	Developing Agent
Sodium Sulphite (anhyd)	100	100	45	Preservative*
Sodium Hydroxide			19	Accelerator (strong)
Borax	2			Accelerator (weak)
Potassium Bromide			15	Restrainer
Dev. time (20°C)	17–20	8–10	2 mins	

Weights in grams, to give 1 litre of sol.
*In D.23 also acts as mild accelerator

3.10

several times over, but you must gradually increase development time. This is because developing agents gradually get used up and by-products from the films themselves slow the action. Even unused developer slowly deteriorates, being affected by oxygen in the air, particularly if the bottle is only part full, or unstoppered.

Other developers are designed as 'one shot'—you dilute from a concentrated solution, develop, then throw it away after use. This gives very consistent results. In all processing it is important to be consistent about temperature, timing (according to recommendations for the film type) and agitation.

Fixing

Following a rinse, or better still a weak acetic acid stop bath to halt development at exactly the right moment, the film needs fixing. 'Hypo' (sodium thiosulphate) or the more expensive rapid fixer, ammonium thiosulphate is used. The fixer solution also needs an acidifying agent to counteract any carried-over alkaline developer. Often it has additional ingredients to harden the emulsion, see table 3.12.

Fixer is always used over and over again, lasting much longer than developer. Eventually, however, it accumulates rinse water or stop bath, and the unexposed silver salts dissolved from the films. Fixing agents themselves also grow weak. You can see when this is happening because it begins to take longer for films to lose their milky appearance. Generally speaking leave films fixing for about twice as long as they take to clear. Then wash for 20 min to remove all soluble chemicals.

Professional laboratories using large vats of fixer have special methods to actually remove the accumulated silver. This is sold and the solution (topped up with new chemicals) returned to use.

Controlling grain

A grainy image can be atmospheric and interesting like figure 3.2, or it can be a disaster because of the way it destroys important detail. You really need to control the situation so you get just the right negative for the effect you want. See figure 3.11.

Two of the most important factors which affect graininess are type and size of film. To get grain like figure 3.2 start with a very high speed film and use the smallest possible format camera (but with a really good lens). Try to choose a subject and lighting

of low contrast, so you can over-develop and still enlarge onto hard grade paper without getting extreme image contrast. Use a maximum energy developer (e.g., Acuspeed) or, for a looser grain result, high resolution developer used with thin coated fast film of about 400 ASA.

For finest grain there is really no substitute for shooting on slow film. Overexposing about one stop followed by two-thirds the normal time in fine grain developer also helps, although this may give you a flat negative if the subject lighting was flat too. And of course, you should bear in mind that the larger the camera you use the less you have to enlarge the grain structure of the negative.

3.11 Grain difference. Top right: Portion of 32 ASA film negative processed in Acutol high resolution developer, and (bottom left) 1250 ASA film give Acuspeed maximum energy development. Both enlarged × 50.

Matching the film to the job

As we saw earlier, panchromatic film of normal contrast is used for practically all general black and white photography. So choosing film really means choosing film speed. Check what is available for your size camera. Films of about 125 ASA are fine grain and suitable for hand-held photography in bright outdoor conditions, or tripod work in the studio. 400 ASA film will handle most types of work. Keep ultra fast 1000 ASA material for really dim existing light conditions, pictures where fastest shutter speeds must be combined with small lens apertures, and whenever you want grain. Film 64 ASA and slower allows you to use long exposures for blur effects and is ideal for pictures requiring finest grain-free detail.

Special requirements. Some negative materials can be given reversal processing so that the film exposed in the camera forms positive black and white transparencies you can project like colour slides. The extra processing steps are explained on page 121. But

FIXER FORMULAE

Chemicals	Plain*	Acid-Fixer	Acid hardening Fixer	Function
Sodium Thiosulphate (crystal)	300	240	240	Fixing Agent
Potassium Metabisulphite		25		Acidifier
Sodium Sulphite (anhyd.)		15	15	Acidifier
Acetic Acid (28%)			45 cc	
Potassium Alum			15	Hardener
Fixing time (20°C)	8	8	8 mins	

Weights in grams, to give 1 litre of solution
*Not recommended, unless a stop bath has been used first.

3.12

3.13 Prints from a 400 ASA film (right) normally exposed and processed, and (left) when over-exposed ×4, normally processed then lightened in ferricyanide reducer. Both enlarged ×25.

for best quality results use film designed for reversal work, such as Agfa Dia-Direct. Of course you can also make black and white slides from negatives by contact or reduction printing on Kodak Fine Grain Positive film. This film has an emulsion just like normal grade bromide paper, and can be processed under an orange safelight using print developer.

Line film, as we have seen, is intended for copying line subjects such as the text you are now reading, diagrams etc. Lith film gives still higher contrast but requires its own lith developer. Both films are difficult to use for direct photography of normal subjects because of their slow speed, and lack of colour sensitivity. So if you want a 'soot-and-whitewash' result it is easier to take the picture first on normal film, make a print, and then copy this onto line or lith film. Compare the pictures on pages 12 and 97.

PROJECTS

P3.1 Try making a simple emulsion. Dissolve 2 grams of silver nitrate crystals in 20 cc of water and, in another container, 5 grams of potassium bromide in 20 cc of warm water with a pinch of gelatin. Combine the two liquids *in the darkroom, under orange safelighting*. The thick white solution of silver bromide which forms can be spread over blotting paper. What happens when you fog a piece of the paper to light, then touch it with a drop of concentrated print developer?

P3.2 Choose a subject full of strong, bright colours—flowers, fruit etc. Take pictures on (a) panchromatic and (b) blue sensitive material (e.g. fine grain positive film or single weight grade 1 bromide paper). Make contact prints from each negative and compare.

P3.3 Look at the subject used for P3.2 through various deep coloured filters. (Transparent sweet wrappings will do.) Which filter produces tone values closest to the print from (b) in project 3.2? Why?

P3.4. How far can you 'up-rate' your film? Using the same subject throughout, shoot frames at ×2, ×4 and ×8 the normal ASA rating. Repeat this series three times, leaving several blank frames between each series. In the darkroom cut the film into three equal lengths. Process these in speed-enhancing developer, giving times sug-

Maximum Suggested Ratings:

Developed in:	Pan-X	Plus-X/FP4	HP5	Recording Film
'Acuspeed'			1600	6400 ASA
D.76	100	400	1200	3000 ASA
'Microphen'	64	250	800	2500 ASA
'Acutol'	64	250		

*See instructions
 packed with developers

(In all cases an increase in grain size
 must be expected)

3.14

gested for 'pushing' one, two or three stops. Make enlargements and compare quality and grain.

P3.5 Select one of your prints which would look interesting converted to pure black and white. Copy it onto line film and print on hard paper.

P3.6 Contact print one of your existing negatives onto (a) normal contrast film, such as Kodak F.G. Positive processed in print developer; (b) contrasty film such as Ilford Line, processed in concentrated print developer. Mount the transparencies, project and compare.

P3.7 How far can you correct overexposure by chemical reduction? Photograph the same subject at $\frac{1}{4}$, $\frac{1}{8}$ and $\frac{1}{16}$ normal ASA film rating. Repeat this series, then give the whole film normal processing. Lighten one set of these overexposed negatives by dipping each frame for various times in ferricyanide ('Farmers') reducer until they all appear normal density. Now make comparative enlargements from these and the equivalent untreated negatives. Compare closely for loss of highlight detail, tone quality, and the appearance of grain. See page 121 for reducer formula.

QUESTIONS

Q3.1 What is the difference between an 'ordinary' and a panchromatic film? How would bright red and bright blue be rendered in the print by these films?

Q3.2 What is a filter factor? If a filter has a factor of ×4 how many stops (and in which direction) should you alter the lens aperture?

Q3.3 List the factors which determine camera exposure. Why is it normally desirable when exposing negative materials to keep camera exposure to a minimum?

Q3.4 List the main constituents of a general purpose developer and briefly explain the function of each. Describe how you could ensure that consistent results were obtained each time a film was processed.

Q3.5 Explain with the aid of diagrams how the reversal process differs from the negative–positive process in monochrome photography. Discuss the relative merits of the respective systems.

4. How Colour Film Works

You don't have to read this chapter in order to take colour photographs, but it will help to explain some practical aspects we shall meet in the next part of this book.

To begin with, just what is *colour*? White light—sunlight for example—is really a whole mixture of coloured wavelengths. They can be sorted out by passing the light through a prism to give a spectrum of colours, like figure 4.2. You get the same effect with a rainbow. Most coloured objects look coloured because they reflect some wavelengths from white light but not others. The pigment in grass, leaves, or the green parts of the diagram reflects mostly green wavelengths and absorbs the rest of the spectrum. The white paper of this page reflects all wavelengths evenly.

Photographic colour film is really a combination of three black and white emulsion layers. One emulsion responds to blue light only, the next records green, and the third red light only. The three emulsions are permanently coated on top of each other (N.B. in the diagram below they are split apart so you can see how each records and reproduces various colours of the subjects).

The diagram shows that, given normal black and white processing, all layers have recorded an image of the subject's white background—because white contains blue, green and red. The blue flag however does not cause

4.1 Colour film has three emulsion layers. This is how they each respond to the camera image and together form a colour transparency.

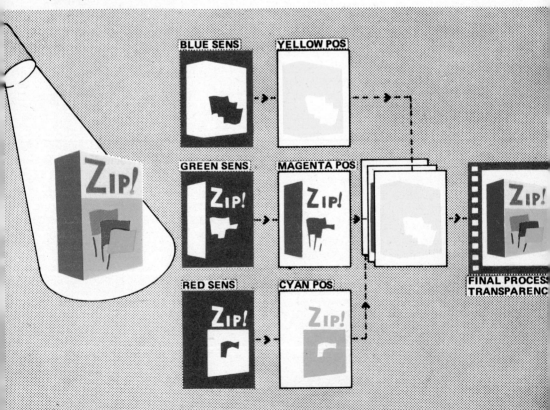

BLUE SENS

YELLOW POS

GREEN SENS

MAGENTA POS

RED SENS

CYAN POS

FINAL PROCESS
TRANSPARENC

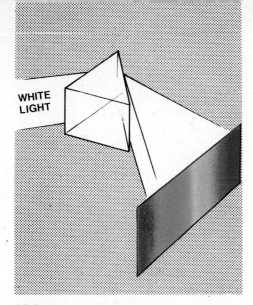

4.2 Colours of the spectrum are fanned out from a narrow beam of white light when this is directed through a glass prism.

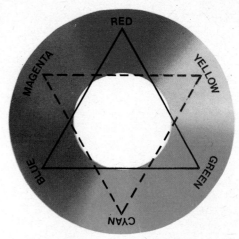

4.3 The 'primary' colours of light and their 'complementaries' or opposites (broken line triangle).

the bottom two layers to darken, although it does affect the top one. Yellow does not record in the blue sensitive layer, but since this colour overlaps into both green and red (its neighbours in the spectrum) yellow is recorded in both these emulsion layers. In a similar way you can see the flags in purply-red (magenta) and greenish-blue (cyan) each record in only two of the three emulsion layers.

So far then we have recorded, in a sort of code, all the colours of the subject. How can we recreate them again? The diagram below shows that when colour slide film is given reversal processing (shown overleaf) a *positive* image is formed in each layer. Each image does not consist of the usual black silver but is formed instead of a coloured dye. The dye chosen is *complementary* or opposite (figure 4.3) to the colour to which the particular emulsion layer responded.

This colour choice seems a bit odd until you remember what each layer is doing. Look for example at the green sensitive layer, which after processing has a magenta image. Now magenta is a colour which subtracts

green from white light and allows the remainder of the spectrum—mainly red and blue—to pass (look back to figure 3.4 on page 36). So the image carried in this layer simply shows where green is *not* present in the subject. Similarly the yellow image denotes where blue is not present, and the cyan image where red is absent in the subject.

Next imagine the images stacked on top of each other and held up to the light. White reproduces white (no dyes here in any layer). The blue flag appears as magenta dye (which subtracts green) and cyan dye (subtracts red) so only *blue* light finally reaches your eye. Trace the reproduction of other subject colours yourself. Can you see now why yellow, magenta and cyan have to be used to subtract unwanted bits of blue, green and red? Blue, green and red dyes here would produce the wrong final colours. Black silver would be useless in any coloured area—it blocks all wavelengths and so prevents the other layers from subtracting or passing their particular colours.

Almost all colour films used today

Ektachrome E-6

1. First Developer
2. Short Wash
3. Reversal Bath
 (Chemically fogs film)

- -

4. Colour Developer
5. Conditioner
6. Bleach
7. Fixer
8. Wash
9. Stabiliser Sol.

(Film can be handled in normal room lighting)

Total time approx. 30 mins.

4.4 Colour film processing in a normal small tank is not difficult but the temperature is critical. For transparency films, there are 9 or more steps.

work on this *subtractive* method of representing colours. Some films form transparencies, others colour negatives (page 47), or even instant colour prints, but the basic colour principle remains the same. (See also the additive colour project P4.3, page 50.)

Try to remember that in photography we are dealing in coloured light. Blue, green and red—the three main divisions of the spectrum—are our 'primary colours'. Yellow, magenta and cyan are our 'complementaries'. (Think of each as opposite to one primary, being a combination of the other two.) If you do painting you will be used to primaries of red, yellow and blue. These apply to *pigments*, which when mixed together behave slightly differently to mixed coloured light.

Processing colour transparencies

Most colour slide films can be pro-

cessed by the user. A few, Kodachrome for example, need complicated processing equipment and are processed by the manufacturers. Ektachrome, Agfachrome etc (figure 4.5) can be home processed using the same tank as for black and white work. The main differences are that you must buy a kit of chemicals to suit your particular film type; there are more stages so processing takes longer; and you must keep to the *exact* temperatures and timings. Figure 4.4 shows a typical processing sequence.

The three most important stages are: (1) *First development*. This forms black and white negatives in each of the three layers. You can see its effect in figure 4.8 overleaf. After a rinse or hardening stopbath (but not fixing) the film is thoroughly fogged; either chemically, or in some processes by exposure to a bright light. This allows the remaining, unfixed halides to be affected by the next stage which is (2) *Colour development*. The special developer turns the fogged halides into mixtures of black silver plus yellow dye, magenta dye or cyan dye, according to layer. (3) *Bleaching* removes the black silver from all layers so that only a positive dye image remains. Other stages such as fixing, washing, stabilising etc are also essential to carry through the complete process. You can see though how this reversal colour processing converts the camera exposed film to a projectible slide, using the subtractive principle of figure 4.1.

Incidentally, the yellow filter layer shown originally between first and second emulsions in figure 4.8 is there to help the manufacturer. He can then use an ortho (blue and green sensitive) emulsion for the second layer and a special green deficient 'pan' emulsion for the third. The yellow filter prevents blue light reaching either emulsion, so they can only respond to green and red light respectively. This filter layer disappears during processing.

The processing of colour negative films is simpler and quicker than transparencies. Basically the kit consists of colour developer, bleacher and fixer, so you end up with an image having complementary colours and negative tones. This colour negative is enlarged onto triple-emulsion colour paper which requires a similar type of processing.

Using transparency films

Two important technical points affect colour transparency films. Firstly unlike black and white materials, you have to use different types of film for different types of lighting. And secondly, the more exposure you give the *lighter* your picture appears.

Colour balance. Each colour film is designed to give correct reproduction when the subject is lit by a particular kind of light source. There are daylight type films for example, and others for tungsten lighting etc. This is because as we saw on page 22, different white light sources give out slightly different mixtures of wavelengths. Each can be given a colour temperature (see page 116) using the kelvin scale:

Blue flashbulbs and Electronic flash	5500K
Sunlight (noon)	5400K
Photofloods	3400K
500 watt studio lamps— floods and spots	3200K
100 watt household bulbs	2800K

The higher the colour temperature the bluer the light.

Black and white films ignore these differences and even the eye hardly notices them unless two different light sources are seen side-by-side. In colour films, though, the three emulsions are carefully balanced in speed and colour response. You can buy colour slide films balanced either for 'daylight' (Kodachrome 64 or Agfachrome 50s for example) or for 3200K tungsten

lighting (Ektachrome type B). A few films (e.g. Kodachrome type A) are balanced for 3400K photofloods.

Daylight film is also correct for flash but if you use it with lamps such as studio floods and spots or other lamps of lower colour temperature it will give you an orange-tinted result, like figure 4.7. Type B film gives a very blue cast (figure 4.6) when the subject is lit by daylight and bluish results with photofloods.

Sometimes you can use these distortions for special effects—to give a warm colour impression, or a cold, spooky image. For greatest accuracy keep to the lighting for which your film is designed. Of course, you may sometimes be half way through a film when you change from taking pictures in daylight to shooting in the studio using spots and floods. In this case you can use a blue conversion filter over the lens in the studio (see figure 4.13) or even over the lamps instead. Work-

COLOUR SLIDE FILM SPEEDS

	ASA	DIN
Anscochrome 500	500	28
Anscochrome 200	200	24
*Ektachrome 200	200	24
*Ektachrome 160 (type B)	160	23
Fujichrome R100	100	21
*Ektachrome 64	64	19
Kodachrome 64	64	19
*Agfachrome 50s	50	18
Kodachrome II (type A)	40	17

*Can be home-processed.

4.5 The speed of colour reversal films is fixed by the manufacturer. However, it can be changed in those films that you can process at home—whether or not you do the processing yourself. Whatever speed you choose, meter accurately, because transparency films are affected considerably by small exposure changes.

4.6–7 Top: Tungsten light (type B) colour film used when mostly daylight is present. Left: Daylight colour film used with fairground tungsten lighting.

ing the other way round—using type B film in daylight—you need an orange filter on the lens. (Super-8 movie cameras always work that way.) As with any filter, you have to give extra exposure. The blue ones, especially, absorb a large proportion of the light. Since most colour films are slower than black and white types to begin with, this is not an ideal way of working.

For some light sources—fluorescent tubes, household lamps etc—there is no suitably balanced colour film. So you have to use the nearest type plus a filter as suggested by the manufacturer. However, slight mismatches might not be too important in atmospheric pictures. In taking a picture of a sunset for example it would be foolish to try filtering its orange light to resemble the midday sun!

Take care over subjects with 'mixed-lighting', e.g. electric lamps and daylight, figure 2.15. You may have to decide which illumination shall appear white, and allow the other to distort. As an alternative, you can filter the

4.8 The effects of processing on the various emulsion layers of colour transparency film. (Relate this to figure 4.1).

BASIC
MULTI-LAYER
FILM

AFTER EXPOSURE
AND FIRST
DEVELOP

AFTER FOGGING
AND COLOUR
DEVELOP

AFTER BLEACH
AND FIXING

4.9–12 Top left: Correct rating (64 ASA) and normal development. Right: The same film exposed as if 125, 250 and 500 ASA, then given increasingly longer first development.

light, as discussed on page 32, or use flash to achieve a similar effect.

Effects of over/under exposure

Overexposure of a colour slide film makes too much silver form during first development. As you can see from figure 4.8 this leaves too little halide to be colour developed. *Overexposure* therefore gives you a colour transparency which is *too light*. Highlight detail, in particular, is missing; and colours look bleached. You can use overexposure creatively to give a high key picture with pastel colours. Unwanted colour and detail in light backgrounds can also be 'burnt out' by exposing only for a darker main subject.

Controls of this kind are valuable because of course with reversal films you lack the usual chance of shading etc at the printing stage. Underexposure has the opposite effect, giving dark shadows lacking detail or colour, and deeper than normal colours in midtones and highlights. Used carefully you can draw attention to important lighter areas in pictures like figure 5.5, letting dark colours become lost.

Light Source		Shooting on daylight type film use:		Shooting on type B film use:		Shooting on type A Kodachrome use:	
⬚	Flash	No Filter		85B	Orange	85	Orange
☀	Sunlight	No Filter		85B	Orange	85	Orange
⬭	Photoflood	80B	Pale Blue	81A	Pale Pink		No Filter
⬭	Studio 3200 K Lamps	80A	Blue		No Filter	82A	Pale Blue
⬥	Household Lamp	80A	Blue†	82C	Pale Blue	82C	Pale Blue†

†*Nearest available filter, but try to avoid.*

4.13 If you must shoot colour slide film with the wrong light source use one of these correction filters (Numbers relate to Kodak filters).

When measuring exposure for colour use whatever meter routine gives you good negatives on black and white film. Averaging the readings from brightest important highlight and darkest important shadow is a generally sound method. Many photographers with separate meters prefer to make one reading through an incident light attachment instead. In general—and because highlights in a picture are usually important—it is better to have a slightly underexposed transparency than an overexposed, light one. Remember this if you are taking several 'bracketed exposures' of a subject at different settings.

User-processed colour films can be uprated (intentionally underexposed) and then given longer first development. You can double the ASA speed of most films this way. Figures 4.9–12 show what happens when you go still further—shadows become empty, there is less range of colours and tones, and grain is enlarged. Nevertheless, the technique can be useful if you have to take pictures in dim lighting or other difficult conditions.

PROJECTS

P4.1 Cover a pinboard with bits of brightly coloured magazine covers, advertisements, and coloured lettering of all kinds. Set up the board in a darkened room and illuminate it with a slide projector. Now place strong colour filters (e.g. Kodak colour separation gelatines) one at a time over the light beam. For each filter note which colours in your display look *darker* and which become *lighter*. This is the way the blue, green and red sensitive layers in colour film would 'see' your subject. It also illustrates the effect of filtering in black and white photography.

P4.2 Direct three projectors, or spotlights, so that they overlap and illuminate a white screen in a darkened room. Filter the three light beams deep blue, green and red. The overlapping primary coloured light should add up so the screen appears white. Place your hand into each light beam in turn and note the complementary shadow colour on the screen.

P4.3 Make three black and white

negatives (on 'pan' film) of the subject for P4.1, one through each of blue, green and red separation filters. Process and contact print onto line film (adjusting development to give similar medium-high contrast to all three positives). Show these black and white slides in three projectors, with the original taking filter over the lens in each case. Register the three images on the screen (have the projectors close together). The colours should add to each other to form a full colour image. This simple *additive* principle was used for early colour photography.

P4.4 Working as a group shoot on a daylight type colour film subjects illuminated by direct sun; blue sky only; studio lamps; household lamps; fluorescent tubes (two kinds); a candle; a flash; and finally a mixture of two of these sources. Note down the lighting in each case. Project the processed pictures and compare. NB. Consider using the same subject—perhaps a portrait—throughout.

P4.5 Select a strongly lit subject in which all the most important and interesting elements are in shadow. Measure your exposure from shadows alone, so allowing other lighter areas to overexpose and 'burn out'. Find a second subject in which the interest lies in the highlights and expose only for these areas.

P4.6 Try processing a reversal color film—Ektachrome or Agfachrome for example. Buy the smallest possible kit and follow instructions carefully. (It will be cheapest to process a batch of several films to avoid wasting chemicals.)

QUESTIONS

Q4.1 The discs drawn below represent patches of coloured light projected so they overlap on the screen; further below are filters held up to white light. Copy the drawings and mark in the missing colours.

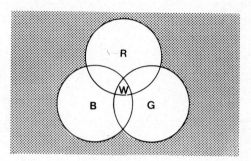

4.14 and 15

Q4.2 Explain the difference between additive and subtractive colour reproduction, and given reasons why modern films employ the latter method.

Q4.3 Explain how colour is reproduced by a colour slide film and list the steps taken when reversal film is processed, using diagrams where applicable. What precautions are necessary at the camera stage to assure satisfactory results?

5. Working With Colour

Colour, like shape and tone, is one of the essential elements of picture making. Colour can strongly influence the mood and atmosphere of a photograph; it provides contrast; it can give harmony or discord. Visually photography in colour is easier than in black and white, because it is more direct. Colour film is able to describe the subject in front of the camera in its fullest sense. At the same time colour transparencies do not allow you the same degree of manipulation in processing and printing possible in black and white, and technically there are more things to go wrong.

When shooting in colour for the first time try to resist photographing every-

5.1 (Top) Warm colours and strong simple shapes help this dramatic holiday close-up.

5.2 (Left) Various tones of green add coolness and give harmony to the mixed elements here.

5.3–4 Colour appearance in landscape changes according to lighting and weather. Top: sun after rain, early evening. Centre: Overcast sky, morning.

5.5 (Below) Suppressing unwanted colour. Exposure was measured from the brightly lit chairs alone.

thing and anything just because it is brightly coloured. On the other hand don't freeze up because of the 'complexity' of colour film. Just consider some of the extra picture making aspects colour offers. You can give emphasis to one chosen element— either because the colours of everything else are subdued like figure 5.5, or very different in hue like figure 5.18. You can make all kinds of elements harmonise because their colours blend well together. Colours can give contrast to a picture which is otherwise very flat and monotonous in tone values. With colour you can record your subject with greater realism and accuracy, or you can use abstract or

incorrect colours like those used in figure 5.13 to give starkly dramatic, dreamlike effects.

Colour brilliance

When talking about colour we often use the word *saturation* to describe its vividness or intensity. Pure colours—the hues revealed when sunlight is split up by passing through a prism for example—are fully saturated. Colours which have been diluted with white, grey or black are weak and desaturated.

Learn to be observant about subtle differences in a colour. Notice how a coloured car is affected by light from its surroundings. A white building or a blue sky reflected from its polished surface desaturates and changes the colour appearance of the paint. Similarly atmospheric haze or mist in a landscape scatters and mixes white light in with the coloured light reaching you from distant objects, so that they appear less saturated.

In photography you can control brilliance of subject colour by viewpoint, lighting direction and quality, and general choice of weather conditions. Compare figures 5.3 and 5.4 for example. Notice how colours in a landscape are transformed when dull overcast conditions change to direct sunlight after rain. Under- or over-exposure will also alter the ways colours record. If you have the most important colour lit either much lighter or darker than the other elements in the picture, then measure exposure only for this main area, other parts of the scene are suppressed. The more they are over or under lit relative to the correctly exposed colour the greater their desaturation. In figure 5.5 the trees in the background have reproduced black; in figure 5.2 the distant background landscape is bleached almost white.

Black and white are useful components in a colour picture. Black tends to make adjacent small areas of colour luminous and bright like the sun glasses in figure 5.1. Adjacent white helps to make colours look darker and stronger. Both help to make the picture look contrasty and bright, even when lighting is flat.

Colour can also be made to look more brilliant by the way it contrasts with adjacent colours and tones. Greatest contrast occurs between a colour and its complementary, particularly when you make the area of one much smaller than the other. Figure 5.18 uses this 'simultaneous contrast'.

Take care over the way you project your colour slides too. Shown with a powerful projector in a well blacked out room they appear far more brilliant and contrasty than any colour print. But in a poorly blacked out room light spill onto the screen will dilute the richness of blacks and desaturate image colours in a similar way to subject surface reflections.

Expressive use of colour

Of course, brilliant, bold colours may not suit the mood of your picture at all. Some of the most effective colour pictures use very few colours, but have a full range of tones and tints. Using just one dominant colour has a unify-

5.6 'Warm' and 'cold' colours.

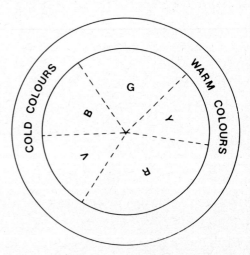

5.7 Compare this black and white image with the coloured version on page 60. Notice how tone contrasts replace colour contrasts, and the picture loses its main centre of interest.

ing effect—other hues play a supporting and subordinate role.

Colour harmony. When you are mixing various coloured elements in a picture decide whether you want harmony or discord. A picture such as figure 5.2 uses mostly hues and tones of green. The overall effect is harmonious, gentle and quiet. Colours which harmonise together well are generally found adjacent to each other in the spectrum or colour circle.

A picture like figure 5.17, full of strong intermingled colours more or less equal in area, gives a jazzy, discordant effect. The picture is lively but unless you are careful such extreme use of colour can easily destroy the subject's form. One interesting way of using such a confusion of colour is to pack it all into a small enclosed area of the picture, contrasted by a larger, more ·sober, muted colour surround, figure 5.16.

Colour and mood. Aesthetically, colour is a very emotional influence in pictures. We associate certain colours or combinations of colours with other experiences. Colours within that part of the colour circle containing red and yellow are considered 'warm' colours.

Cool or 'cold' colours are found within the green and blue half.

The comfortable atmosphere of a room interior or the brilliance of an autumn landscape can be helped by use of warm colours. So be selective over the colour of items you include in your picture.

A colour scheme making use of blues, greens, greys and similar cold colours can increase the tranquillity of a river scene, the bleakness of an empty deserted house, or even an inhuman appearance of a portrait. Sometimes you can achieve this by simply changing to an artificial light film, or using a blue conversion filter.

If you are photographing something fairly small in size—a head and shoulders portrait perhaps—you may be able to use light reflected from coloured card (or a coloured wall or curtain) to get the effect you want. Buy a few pale colour correcting filter gelatins in various tints so you can always slightly warm up or cool down the general colour scheme. Try also using them only half across the lens. For expressive colour photography strict accuracy is unimportant—in fact you might be restricting your ideas by

T01298)

5.8–12 Abstracting shape and detail. (Top) refraction through water, and glass; (bottom) by reflection, and image movement. (Left) A coarse-grained image by enlargement through a microscope.

sticking too literally to the manufacturer's suggestions for 'correct' colour balance and exposure.

Colour abstraction Don't overlook the possibilities of colour itself forming the main interest in a picture. Sometimes the subject is real but transformed by colour distortion, like the fairy-tale castle in figure 5.13 which was shot on infra-red film through a deep green filter. (This film is discussed on page 84.) You can also make a startling interpretation of a mundane subject by having your colour slide film processed as a colour negative, figure 5.14. Think ahead and try to estimate how it will appear in negative tones and complementary colours.

Another approach, in the studio, is to use strongly coloured acetate sheets over some or all of your lights, to give

5.13 Distorted colours given by infra-red
Ektachrome (using a deep green filter).
5.14 Right: Colour slide film given colour
negative processing.

violent changes of hue within your
subject. Like theatrical stage lighting
this gives you complete control over
colour of background, the main light,
shadows etc. See figure 7.12, page 76.

Colour also gives an extra dimen-
sion to abstract designs. You can
translate your subject into an interest-
ing pattern or structure of coloured
shapes, deciding how much to destroy
its original details. Figures are turned
into plastic blobs of coloured light by
photographing through water or glass,
or just setting the lens wildly out of
focus. Abstract blur lines formed by
movement of the camera or subject
can make interesting coloured pat-
terns, like the night shots on page 85.

By using a very coarse grain colour
image you can achieve a semi-abstract
effect similar to pointillism in painting.

Colour is broken up into irregular dots so that fine detail is lost, yet broad details of subject colour and shape are preserved. Figure 5.12 is one example. Technically coarse grain is quite difficult to achieve because most colour films are slow and fine grain. Use the fastest type you can buy, and if possible up-rate and push its processing 1–2 stops. Better still, make the image of your subject very small (distant viewpoint, wide angle lens) on fast colour film, then rephotograph the processed transparency through a low power microscope onto slow reversal colour film. Other expressive ways of controlling colour, such as hand-tinting black and white images, are discussed in chapter 8.

Objective recording of colour

Of course, there are times when you don't want to manipulate the colour in a colour photograph, but record the subject in front of the camera in the most objective, accurate way possible. Your problems are mostly technical, so watch the following points:

Make sure the film is not out of date. Use the same brand of film throughout a series of pictures (dyes vary brand-to-brand giving marked differences in colour when transparencies are compared). Be careful about the colour and evenness of your lighting. Avoid mixed light sources and try not to photograph subjects anywhere near coloured surfaces, such as walls or curtains. Lamps should be the same voltage as the electricity supply and of course the right colour temperature for your film type. Check that floodlight reflectors are not yellowed with age. Flash is very consistent in colour and intensity, as well as being a portable light source.

If you use a separate exposure meter remember to give extra exposure when using close-up rings or bellows attachments (page 121). And at exposure times longer than about 1 sec most colour films behave as if slightly slower than their ASA rating. See 'Reciprocity Law Failure' page 119. For critical work you may need to give more exposure and use a weak correcting filter—check the instructions from the film manufacturer.

Have your pictures processed soon after exposure—preferably within a week. If you process colour yourself try to use the same kit of chemicals for the whole batch of pictures and take the greatest care over temperature, timings and agitation to give film-to-film consistency. If this all sounds rather intimidating remember we are aiming for a result which can be compared side by side with the original subject for accuracy—the most difficult test for any colour film.

When copying paintings, drawings, stamps etc, try to use a background of neutral grey or black. White or light coloured backgrounds may give slight flare. Be particularly careful about placing your lights if the subject is behind glass—this may give reflections which desaturate colours and weaken shadow tones. Use a pair of lights well back to give even, overall lighting, set at about 45° to the subject. (A polaris-

5.15 A slide copying attachment on a camera with extension bellows. Slide (S) clips behind diffuser.

ing filter can strengthen colours by eliminating surface reflection of white light from glass, gloss paint etc., page 119.) The colours of close-up specimens show up most strongly against a neutral grey or muted colour background, or alternatively try laying the subject on white opal plastic illuminated from below (using the same colour temperature lighting). Mask off the plastic all round with black paper just outside the picture area.

Colour recording through the microscope can be very rewarding, but make sure the lighting (sunlight or suitably filtered micro-lamp) is the correct colour for your film, and the condenser is adjusted to illuminate the specimen really evenly. Try to use a single lens reflex body with a through-the-lens-meter over the microscope draw tube. If the camera lens cannot be removed focus it for infinity, and control exposure by the shutter, not lens aperture.

To copy an existing colour slide, remove any dust etc and lay it on backlit opal plastic. You will need extension rings or bellows able to position the lens twice its normal distance from the film to get an image the same-size as the original. A slide copying attachment like figure 5.15 is quicker and more convenient. This fits over the *front* of the bellows attachment and lens, and holds the transparency in front of a plastic diffuser. You just point the whole unit towards a suitable light source.

The main problem when slide copying in colour is that image contrast always increases. Original pictures which had soft, frontal lighting therefore reproduce best. Overexposing the copy one stop (or rating the film half speed), then giving only 70% normal first development will help reduce contrast. The same applies to the making of black and white negatives from colour slides—use normal contrast panchromatic film, overexposed and underdeveloped.

Unusual subjects

Colour TV. You can make good colour transparencies from pictures on colour TV. And mis-adjustment of the set controls allows distorted colour effects. Use daylight type colour film, darken the rest of the room and choose a shutter speed of 1/15 sec or slower. This means choosing fairly static action on the screen, but longer exposure times which record moving elements with considerable blur are also interesting—pick scenes where movement occurs against plain, dark toned backgrounds. Use your exposure meter for TV in the same way as when copying a photograph.

Street lighting. Most towns are lit at night by orange (sodium) or bluish (mercury-vapour) street lights. These give very bizarre colour rendering, particularly for portraits, see figure 5.20. For mercury vapour lights shoot on daylight film, using tungsten type A or B for sodium lighting.

Fairs, discos. Scenes filled with coloured lights at night make good subjects for colour photography. Try to decide how you want your final picture to appear. Working at night with the camera and lights both stationary you often just get boring, contrasty specks of light in a sea of black. It is usually better to record some suggestion of the surroundings by shooting at *dusk*, or at least when some weak overall lighting is present too. If your subject is a campfire, fairground, seaside illuminations etc, use tungsten light film. Fireworks and flashing disco lights have a colour temperature more suitable for daylight type film.

If the lights themselves are moving try giving a time exposure at dusk or after dark, with the camera firmly mounted on a tripod. Exposures of about 1–4 sec at f 16 on 80 ASA film records cars, roundabouts, etc as various patterns of blur. Use a neutral density filter if you want longer times without overexposure. For fireworks

5.16 A confusion of colour can look more effective packed onto a small, local area. (Microscope picture).

such as rockets try keeping the shutter open for the duration of the burst, using your smallest lens aperture. See also page 85.

You can make static lights more interesting and lively by moving the camera. For a 'light curtain' effect (figure 5.19) try tilting the camera up or down the tripod during exposure. Just random movement—walking along a busy street at night with the shutter open—will trace out extraordinary patterns. The various entwining colours from cars, signs etc record with depth and pattern which would look too muddled in black and white.

5.17 Top left: Colours here attract but compete too much with each other.
5.18 Left: An area of colour stands out against a complementary or contrasting colour background.

60

5.19–20 Top: A single row of lamps on a building created this light pattern. The tripod head was tilted in jerks during a time exposure. Right: Portrait exposed at night under orange sodium street lamp. (Tungsten film).

Ephemeral colours. Do not overlook short lived, transitory colours which are often very beautiful. A rainbow is an obvious example, but you will also find brilliant, strange colour patterns reflected from oily surfaces after rain, figure 5.21, or soap bubbles or long playing records (if you can work sufficiently close). Choose your viewpoint carefully—colours will appear strongest from one particular position relative to the light. Measure exposure for the patch of colour alone, not the often darker surroundings.

It is important when exploring colour photography to allow yourself sufficient film to experiment visually and technically. Of course, this will

5.21 Colours reflected from drops of oily water on new tarmac road surface.

mean you have many frames which are failures or mistakes. Keep such transparencies for use later in constructing pictures by montage or superimposition, discussed in chapter 8.

PROJECTS

P5.1 Obtain pieces of fabric or card about 3–4 in square, in each of the following *bright* colours: blue, orange, yellow, violet. Now cut midgrey card or paper into 1 in squares and place one square in the centre of each coloured area. Compare the greys. Do they appear to differ, and if so, why?

P5.2 Selecting suitable subjects take two colour photographs. The colour scheme of one should be based on a single hue using a wide range of tints and shades. The second should use many hues but all at equal or similar shades.

P5.3. Make a set of four colour transparencies of related subjects in which the predominant colours are *either* (a) 'warm' or (b) 'cool'; showing a variety of approaches to the use of colour.

P5.4 Seek out coloured lights at night—busy traffic, decorations, signs, windows in tall buildings etc—and produce four interesting colour transparencies.

P5.5 Making appropriate use of colour, lighting, composition and expression take two portraits of the same person. One should show your sitter as gentle and friendly, the other as sinister and frightening. Keep the clothing, setting and any make-up identical in both colour pictures.

P5.6 Set up a still-life group of neutral coloured objects (white eggs, paper sculpture, tennis balls etc) on a plain black background. Illuminate this with a single light source appropriate to the colour film you are using. With coloured card placed just outside the picture area gently tint parts of your subject by reflection. Make a series of five pictures, changing reflector colour and position.

P5.7 Select and arrange a subject containing colours of related hues. Make an objective record on colour transparency film. Using the same subject produce a set of *four* abstract colour images.

P5.8 Choosing appropriate subjects and lighting, produce three colour pictures which rely largely for their effect on muted, subdued colours.

P5.9 Make a series of 3–4 abstract colour images of the human figure. Consider the possibilities of focus, lighting, movement, and the effect of colour filters.

P5.10 Find examples of the use of colour by the following painters: Rembrandt, Turner, and Seurat. Compare their choice and distribution of colours and the influence this has on the mood or atmosphere of their pictures. Would any of these paintings work equally well in black and white?

QUESTIONS

Q5.1 What is meant by colour temperature? What is its significance in colour photography? Explain what the effect would be of mixed daylight and tungsten illumination when recording on daylight colour film. How would you correct for this difference. Give examples where mixed lighting could be used creatively.

Q5.2 Describe the characteristics of a subject you would select and the operating method which you would adopt to produce a high key colour photograph.

Q5.3 List the controls which may be effected by the photographer when using reversal colour film to ensure maximum fidelity of colour reproduction. Describe the effect on colour reproduction resulting from lack of control of *four* separate variables.

Q5.4 Discuss the main differences between black and white and colour photography as an expressive medium.

6. Elements of Composition

Composition is a general term used to describe the visual structure of an image. The photographer Edward Weston called composition 'the strongest way of seeing things', and unlike most technical aspects of photography it has no set rules, no step-by-step routine. Composition is mostly concerned with organising your eye, camera and film to solve visual and aesthetic problems. For example, 'how can one important element be emphasised in this scene' or 'how can this picture be made to look active and exciting... or tranquil and calm'. Using various composition devices you can create a strongly structured, visually unified image and at the same time strengthen the points you want to make through your photography.

6.1 A picture making strong use of linear perspective and size change to convey depth. (28 mm lens).

Dealing with space and depth

Like drawing and painting, photography is much concerned with visual illusion—mostly the problems of describing three-dimensional reality on the two-dimensional surface of paper or film. The two most important ways you can make a picture appear to show space and depth are by using (1) linear perspective, e.g. divergence of lines approaching the viewer and changes of size with distance, like figure 6.1; and (2) aerial perspective in which objects near and far appear to differ in tone and colour saturation, figure 6.3.

Linear perspective. Literally, 'perspective' means 'see-through'. This refers to the effect that the picture sur-

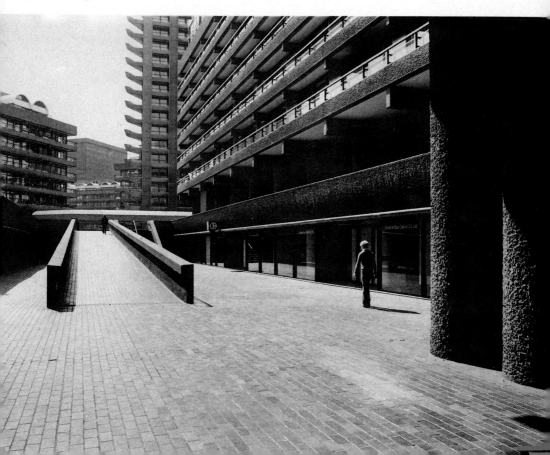

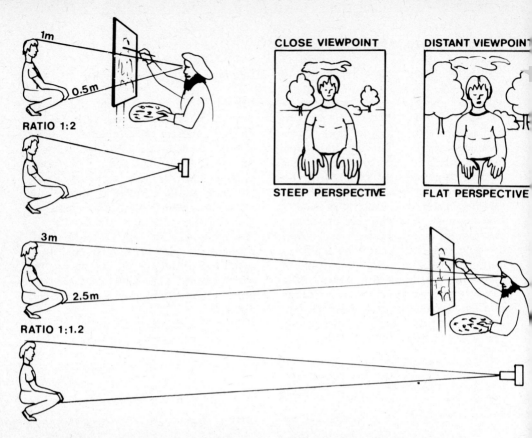

RATIO 1:2

STEEP PERSPECTIVE

FLAT PERSPECTIVE

RATIO 1:1.2

6.2 Whether you are drawing or photograph-
ing, a close viewpoint gives steepest perspec-
tive and size change. Moving back reduces
the ratio of distances between nearest and
furthest parts of the subject. See figures 1.6–8.

6.3 Right: Here most of the feeling of
depth is produced by aerial or atmospheric
perspective.

face ('picture plane') in a perspective drawing acts like a window onto a scene. Perspective allows you to read subject depth as well as height and width through a construction of lines (hence 'linear perspective') which shows oblique surfaces tapering towards the background. Everyone is familiar with seeing this apparent convergence—in which objects appear smaller and closer together towards the far distance. The more steeply such lines converge and the greater the difference in scale, the deeper, the picture appears to the eye. A 'depth' picture with steep perspective involves the viewer, making him feel close to foreground objects and distant from the background, very much a part of the scene. A flatter perspective image is

generally more remote, with the space between foreground and background compressed so that almost everything appears presented on the *surface* of the picture plane.

Painters traditionally use more flattened perspective than photographers. They usually aim to minimise scale changes which alter the true proportions of one element to another. We know from chapter 1 that the way to do this is by choosing a distant viewpoint from which to draw or photograph. From here differences in near and far size become less extreme, figure 6.2. Leonardo da Vinci told painters to 'Stand at a distance three times the size of the object you draw' for 'correct' perspective. This angle of view (18°) is good advice for commis-

sioned portraits because steepened perspective is generally unflattering. And remember that a painting hung on a wall is mostly viewed at a distance. From here the viewer uses a narrow cone of vision and so accepts the picture's reduced linear perspective as accurate and realistic.

The photographer of course can use a range of lenses to fill his picture area from any of a range of distances. You therefore have almost as much control over your 'drawing system' as the painter—moving back and using a long focus lens (or enlarging part of the negative later), to get flattened perspective, or moving closer (with a normal or wide angle lens) for steepened perspective. Don't overdo this of course. As we saw in chapter 1, fisheyes and extreme long focus lenses give very unreal looking images.

You can further strengthen your chosen linear perspective by choice and treatment of subject. A strong linear shape like a river, a tree line or row of houses running from foreground to horizon gives a deep effect, see figure 6.11. In black and white this can be made stronger by careful printing on hard paper to make the line forms bolder.

A shallow space picture is helped by a more flat-on viewpoint, perhaps showing your subject against a plain background such as overcast sky or a studio backdrop, which offers the eye no details to compare for scale. Try keeping foreground parts of your picture empty of strong elements too.

Aerial perspective is a compositional device for implying depth long used by painters who portray the most distant parts of a scene softer in tone and colour than the foreground. The idea is to duplicate the atmospheric effect

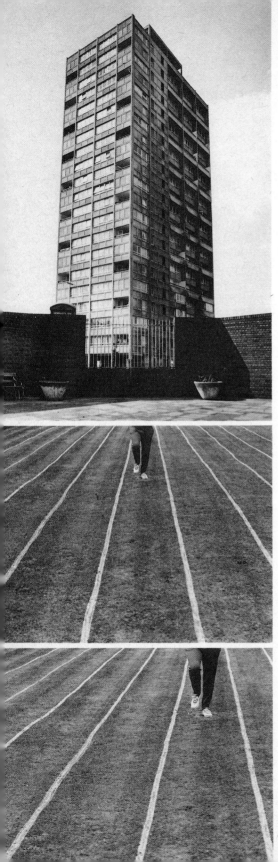

which occurs in nature. The same principle can be used in studio photography where objects at different distances can be lit to different values. In landscape photographs tones often become weaker and colours diluted and colder in hue in the more distant parts of the scene. Atmospheric perspective is further helped by hard side or backlighting, slight ground haze, and overlapping but tonally separated objects at different distances (e.g. trees in a wood, or a range of hills).

Flat, frontal lighting, clear atmospheric conditions and a viewpoint showing least tonal change from foreground through to background gives shallow space. Whenever possible try to combine the effects of linear and aerial perspective to strengthen rather than nullify each other.

Framing and proportions

Most photographs are 'content orientated', meaning that the subject in front of the camera is of greatest importance. Others are 'structure orientated'—the subject is less important than the way it is treated (figure 6.16 is one example). Either way, your care in arranging the various elements of the composition within the frame can make the difference between a random snap and a strong, unified picture.

Studio portraits, still lifes, architecture etc of course lend themselves more easily to considered use of composition than 'snatch' pictures of action. (However, your eyes can learn to apply the same principles, almost intuitively, to these subjects too.) Start off by using the viewfinder as you would a sheet of paper. Firstly consider frame proportions...horizontal

6.4 (Top) A viewpoint chosen to produce false attachment of foreground to background gives a caged-in feeling to this building.

6.5–6 Creating an off-centre vanishing point. The lower picture was enlarged from the left half of the same negative used above.

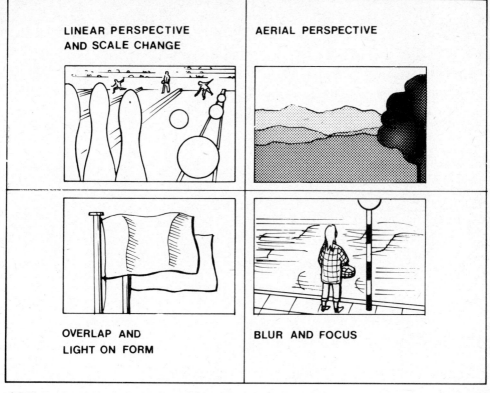

| LINEAR PERSPECTIVE AND SCALE CHANGE | AERIAL PERSPECTIVE |
| OVERLAP AND LIGHT ON FORM | BLUR AND FOCUS |

6.7 The main methods of generating 'depth' in a photograph.

or upright? ... and should you plan to crop to a narrower or squarer shape? Sometimes this is determined by the subject shape itself. Usually, you have a choice of viewpoint, so you can decide the best proportions and placing within the frame.

Choice of framing allows you to combine quite different isolated elements in the same picture (look at figures 1.9 and 9.10). Similarly, the height-to-width proportion you use to help to control how you picture is viewed. A tall thin shape is scanned vertically, emphasising height, a long low one is strengthened horizontally. In this way vertical or horizontal lines or movements are increased or decreased in importance.

The concept of the 'golden mean' was long favoured in composition; suggesting that placing the main sub-ject at the intersection of lines dividing vertical and horizontal zones in an 8:5 ratio (figure 6.9) is most pleasing. This is useful as a compositional guide in photography but must never be slavishly adopted. Figure 6.10 uses this classical sort of placing; figure 5.1 which has a symmetrical composition instead still works for its particular (exuberant) theme.

Consider, too the effects of overlap or 'false attachment', within your picture. This means the way a line, tone or colour appears to run into another. A telegraph pole which seems attached to someone's head is a destructive use of false attachment. But in pictures like figure 6.4 or 6.12 very simple attachment of line can help to give a harmonious flow, unifying otherwise diverse elements. The same applies to the corners and edges of the picture.

6.8 Montage constructed by using dozens of cut out magazine pictures, giving complete perspective control. (Brian Knight).

6.9 The four Golden Mean positions for so called 'strong positioning', shown on a 35 mm picture format.

6.10 The main element in the picture below, although small, is placed in a strong, dominant position.

You can choose to make subject lines run into the exact corners of the frame (figure 6.11) so the picture edges become an essential part of the linear composition. Similarly shapes and forms can be made to 'sit' on the base line of the picture or be attached to one side.

False attachment should be used only occasionally and with great care. Be careful too when framing up subjects with plain backgrounds. For

example, part of a figure photographed against a pure white background can end up appearing to have a stump of an arm or leg where this is cut by the white print border.

Giving emphasis

Most photographs are strengthened and simplified by having one main subject or 'centre of interest'. In a picture of a crowd this may be one figure waving a flag; a landscape might feature a cottage or a group of trees. Occasionally two equally important elements may work, e.g. where a relationship is being shown, but a picture is easily split and weakened this way.

Having thought about and picked your main subject there are various ways composition can be used to bring it into prominence.

Juxtaposition and viewpoint. Show the main element in a strong position relative to its surroundings. You might for example make it the lightest or darkest item in the picture or place it *against* either of these tones. Doorways are particularly useful here—a figure outside a house can be isolated by carefully positioning in front of a dark open entrance, or a bright closed door. Always remember how the eye is attracted to where strong darks and lights are adjacent, and make sure the emphasis is where you want it to be. Use background shapes and linear perspective to give strong lead-in lines (including false attachments). The simplest picture structures are usually the best. Don't allow the importance of the main subject to be diminished by competition from a strong pattern or colour. See figure 7.13.

As we said earlier, working with a still-life in the studio you can control all these factors; in a fast changing situation outdoors the best you can do is pick the most useful viewpoint and wait for the right moment. For example, if foreground or background are confusing and irrelevant, de-clutter

6.11 A picture in which the corners and edges of the print are carefully related to lines within the image.

the picture by aiming high or low so that most of the frame is filled up with sky or ground. Alternatively use shallow depth of field or, if the subject is moving, pan the camera at a slow shutter speed and blur the unwanted detail. You can also choose long focus lens or close viewpoint which cram the picture with the main subject, excluding everything else.

Remember the value of emphasis by colour contrast, including the use of colour restricted to either the subject or its surroundings. In black and white photography try to predict the final tone values of colours and make changes, if necessary, using a filter.

Other devices

Filling empty foregrounds is often a problem in landscape photography. One solution is to lower the camera to near ground level and use out-of-focus grasses, foliage etc to fill the space. Usually this relates well in colour too. If the ground is flat and smooth (like a street surface) this approach effectively obliterates foreground from your picture altogether. Another way is to choose a foreground which is in shadow or use a cast shadow, like figure 6.13. In fact using a wide-angle lens can make an interesting shadow shape into a strong com-

6.14 Figures placed to use foreground and background, but no mid-distance.

6.12–13 Top: Avoiding flat, empty foreground by low level viewpoint and tilted camera. Above: High viewpoint and wide angle lens make use of the foreground shadow as a lead-in, loses cluttered horizon.

positional element. Empty skies are a similar problem. You can fill this area with tree foliage, shoot through an arch or similar frame, or (in black and white) darken a blue sky with a yellow or orange filter. Filtering will also make a feature of any clouds.

Often a picture with foreground, mid-distance and background elements is strengthened and unified if all three zones can be linked in some way. This may be possible through repetitive shapes, or a common colour scheme, a simple linear element which threads its way through all these zones, or by simply using a foreground shape to frame the whole. Figure 6.14 is structured with the main subject in the immediate foreground and a secondary element in the back-ground—the two being linked through an empty middle zone. Perspective is steep, giving strong differences in scale. You can use a device of this kind to relate person to person, or person to environment in a dynamic way.

Remember that a camera lens normally gives you a central 'vanishing point' for linear perspective. This point can be offset (e.g. lines made to converge towards an off-centre figure or to one edge of the picture) if you have a shift lens or camera with cross front. You can get a similar effect by enlarging half of the negative. (Figure 6.6.)

One good way to bring order to an otherwise chaotic confusion of forms and colours is to keep them enclosed within some simple shape. Lots of small objects can be brought together by showing them in some form of container. Or you might decide to photograph through a window, or have things reflected in a mirror. Shapes can always be improvised—even if you just use the triangular silhouette formed under someone's arm.

Sometimes you may need an opposite approach—jazzing up an otherwise rather mundane subject. Notice the effect of speckled shadows from leaves etc, or hard oblique lighting of textures, or even local diffusion (figure 8.7) all of which help to break up dull familiar forms and change the appearance of selected parts of the picture.

The character of the dominant lines in the picture also affect its mood. Subjects with strong horizontal and vertical lines often give a static, stable feel to a composition. But you can decide to photograph them from viewpoints which turn these lines into diagonals, or converging, jagged, even curving lines, which all contribute a dynamic, active feel to the picture. Of course, if your camera allows swing back, figure 6.15, you can use this to elongate or compress the appearance of subject planes, giving a distorted perspective form. This is also possible by tilting the enlarger easel. (In both instances stop the lens well down.)

Fantasy and surrealist effects can use totally artificial space devices, made possible for example by montaging many pictures together. Figure 6.8 was constructed from bits of photographs clipped from newspaper colour supplements. The mixed perspective structures give an effect unlike the way any lens (or eye) could have seen such a landscape. Figure 8.3 on page 81 is another type of example. You can also form a totally false shallow depth effect using the darkroom technique known as bas relief, shown on page 87.

Finally remember that there are too many aesthetic aspects of composition for it ever to become a science, or set of rules. It provides guidelines and suggestions—judge for yourself whether they really work in the manner intended. A step-by-step approach is impractical, partly because of lack of time when actually taking pictures, mostly because too many factors are inter-related. Viewpoint for example may be fine for the main subject itself but how do foreground and background relate? From this position is the lighting from the best angle and does shadow direction, length and general contrast help or confuse? Should the picture be upright or horizontal? Are you making constructive use of perspective, overlap, colour and tone values? Change any one of these factors and several of the others are affected too, so a compromise becomes essential.

6.16 Shadow can strangely distort the appearance of space. Look at the way these two figures have roundness and depth, but others seem all on one flat plane, like a billboard poster. (Long focus lens.)

6.15 A camera with swing back allows some change of image shape.

NORMAL **SWING BACK**

Although your tools are different to those used by the painter many of the same compositional decisions have to be made. You can learn a lot from looking at drawings and paintings, thinking about how the artist has used some of the devices we have been discussing.

PROJECTS

P6.1 Looking through viewing tubes of various lengths (see page 8), find a suitable subject and observe how depth is conveyed by consciously noting (a) apparent convergence of parallel lines; (b) overlap of shapes and forms; and (c) aerial perspective. Notice the differences which would occur if you were photographing with lenses of these focal lengths.

P6.2 Find examples of both a photograph (e.g. magazine illustration, advertisement etc.) and a painting for each of the following: (a) A picture which describes 'deep' space mostly by linear perspective; and (b) one describing space mostly through aerial perspective. Suggested painters; Carravagio or Georges de la Tour, Vermeer, Monet and Vlaminck.

P6.3 Produce three colour pictures of a landscape which contains one chosen centre of interest. Use composition to strongly emphasise this element. Shoot each picture from an entirely different viewpoint. NB. Your pictures need not all be taken at the same time.

P6.4 Take four black and white pictures, each of which includes a *cast shadow*. You can use your own shadow, or one cast by a variety of objects shown or unshown, but in each case the shadow must form an integral part of your picture.

P6.5 Photograph several rough-cut cubes of wood on an appropriate studio background. Take one picture in which deep depth is suggested mostly by linear perspective, then another which presents this illusion mostly through aerial perspective.

P6.6 Working in the studio, set up suitable photographs cut from magazines etc together with a simple three-dimensional object, e.g. a seed box or cardboard carton (unlettered), bricks or stones. In this way mix real and illusionary space and composition to produce a surrealist type of picture.

P6.7 Make a series of three photographs of a figure in an identifiable environment—street, room, garden etc. Your composition should use the figure (a) in the foreground; (b) in the background; and (c) positioned near the corner of the frame, in each case balanced with or related to elements elsewhere in the picture.

P6.8 Make a photographic study consisting of five black and white pictures to portray one of the following concepts: (a) power; (b) space; (c) growth.

P6.9 Using your camera as a notebook, analyse shapes found in your local architecture. It is not intended to show buildings as they appear to the casual eye but to select areas which are strong in design and rich in texture and tonal variety. Select six final photographs.

QUESTIONS

Q6.1 Write detailed notes to explain how the following factors may be used judiciously to control picture content, both technically and aesthetically: (a) viewpoint; (b) focal length of lens; (c) depth of field.

Q6.2 Describe an operating technique which may be employed to obtain the following qualities in a photograph, giving examples of its practical application in each case: (a) a sensation of movement; (b) an illusion of three dimensions; (c) a representation of fine surface texture.

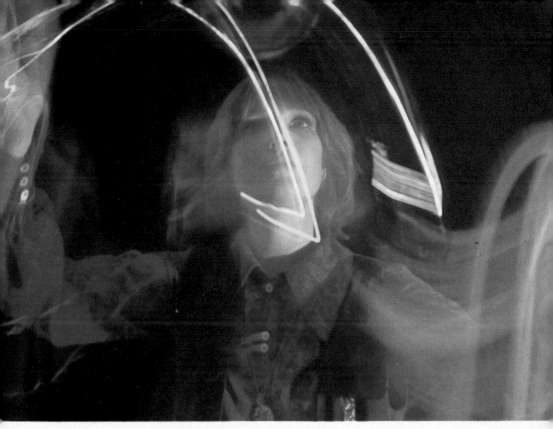

7.1 A time exposure in the studio as the girl waved plastic sheeting. Daylight colour film, studio lamps.

7. Working in a Studio

Photography in the studio is rather different to working anywhere else. After all, the subject, lighting, background, and camera position are (or should be) completely under your control. At the same time its artificial environment, with lights, backdrop, reflectors and other essential bits and pieces can make people feel awkward and self-conscious. Even the degree of control can be a disadvantage—you can 'over-do' the lighting and arrangement so that both portraits and still life subjects begin to look artificial. However, without doubt the studio is the best place to experiment and learn the craft of lighting and subject composition. It allows you to take pictures, check results, and if necessary re-shoot after improvements.

The simplest form of a studio is a bedroom or living room, blacked out or used after dark so that all lighting is completely controlled from within the room. If you don't have photographic lighting a desk lamp, domestic spotlamp, even hand torches are adequate for black and white still life work. The most essential equipment, after the camera and exposure meter, is a fully adjustable tripod. A large sheet of thick cartridge paper, which can be bought in various tones and colours, can be used to form a curved plain background.

A much more efficient studio set-up is shown overleaf, where a larger room has been cleared. The window has a removable blind and the glass behind is covered with tracing paper

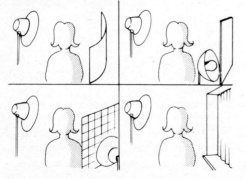

7.2 A room cleared to form a temporary studio. The table with curved card background is used for still lifes.

so that daylight is diffused and can be used as a large 'floodlight' if needed. Spots and floods, as described on page 23, are mounted on fully adjustable floor stands. You can also support flash in this way. The 'boom light' is an ideal way of positioning top/back lighting of figures, backgrounds etc.

7.3 Methods of reducing light contrast without creating a second shadow.

The background surface itself may be a white painted wall, or (if you can afford it) a wide roll of seamless paper. You need a stool for your portrait sitter and one or two reflector boards and diffusers. These can be made from card, or tracing paper attached to a simple frame. For colour work, try to avoid rooms with coloured walls or a ceiling which may tint your pictures. White surroundings form valuable 'bounce' surfaces for lighting. Have a table for still life subjects; you will also need lots of bits and pieces such as sticky tape, string, bits of wood to prop things up with, modelling clay, wire and drawing pins.

Studio portraits

Before you get too absorbed by lighting and exposure techniques, decide

what sort of picture you want to make. Portraits are about character and appearance, and you will probably be aiming at a photograph which sums up the essence of the sitter—his humour, seriousness, liveliness etc. In general, aim for a picture which identifies the individual in an interesting manner, as well as being characteristic of his or her personality. Decide whether the clothes worn compete too much with his or her face. If possible alter them as you want. Should the picture be essentially high or low key, or have one predominant colour scheme? This brings in the tone and colour of background as well as clothing and lighting generally.

Consider how much of the sitter you need to include—head only; head and shoulders; half-length; three quarters or full-length? Which viewpoint gives the best head and body shape, and emphasises important features? Should the head be square-on, three-quarter or profile to the camera? Consider your camera distance. A long focus lens used from a distance helps suppress forward projections such as the nose, and the sitter also feels less 'crowded in' with equipment.

As always, build up your lighting one scource at a time. Firstly the main light—hard like sunlight or soft like hazy daylight? Direction and height of this light source determines the positions of shadows, changing the face shape from rounded to oval and extending or flattening the features (figures 2.34–40).

Lighting at this stage may well be over contrasty. To compensate you could set up a reflector board, large enough to give an even effect, near the

7.4–5 High key portrait and, below, a low key portrait.

7.6–7 Setting the scene. A cut-out window shape projected onto the wall suggests environment in an otherwise bare studio.

7.8–9 A large diffused flood plus a reflector on the right illuminated this group. Above: Strong use of head and hands to convey character. Lit by floods 'bounced' off a large white reflector.

7.10–11 Left: Black background and dark trousers used to emphasise the shape of the sitter's arm. Below: Spotlights filtered with red and cyan acetates change subject colours, strongly separate background.

shadow side of the figure. If this is not strong enough it could be lit separately by a second lamp. Figure 7.3 shows some other solutions—notice that they all preserve the 'natural light' basis of only one set of shadows.

Now consider the background. A white wall can be made to appear any tone from white through to black by comparison with the main subject, but you must have enough studio space to light one without affecting the other. To introduce colour, place coloured acetate in front of the lamp or using a background of coloured paper or fabric. Try to avoid extremes of tone pattern or colour which may dominate the figure. Pure black or white backgrounds are quite difficult to use successfully—they easily overwhelm the subject by overexaggerating outline or practically obliterating it. If you produce a graduated tone across the background, it can either blend in, or interchange, with the tone values of your main subject. You can even project shapes on the background like figure 7.6, to imply environment. Additional lights are sometimes justified to illustrate some local area such as dark clo-

thing or hands, or for top lighting the hair. When photographing pairs or groups of people a large source of soft directional lighting gives a more natural unifying effect than trying to light each individual separately. See figure 7.8. Try not to make your lighting too rigid. Consider your sitter, who must be allowed some flexibility of movement and expression, or your portraits will all look terribly wooden. Similarly try to use a lens aperture small enough to allow reasonable depth of field. (Always focus on the eyes.) Relax and talk to your sitter, or at least give him something to do. By having the camera on a tripod with a fairly long cable release you can chose to stand left, right above or below this lens position. The sitter, looking at you, will then record on film gazing in the direction you require without actually having to be instructed. Try not to keep adjusting your lighting. Decide what looks best and then shoot numerous pictures concentrating on viewpoint and expression.

Studio still life

Of all subjects, studio still life offers greatest freedom to concentrate and explore composition, light, colour and texture. The painterly choice of fruit, flowers, food—usually grouped with a bowl, jug or candlestick—offer the same challenge to the photographer. It's not so much the subjects themselves as the way they are put together to give a unified, satisfactory picture. Of course you can break away from 'classical' still-life subjects—look at the way a coat hangs over the back of a chair, or a knife and fork appear on a crumpled table cloth. There are probably many things in your room at this moment which could be used to make interesting compositions, given the right attention to detail.

You might pick subjects which relate to a common theme. They may all be in the same material, or have similar colours. Perhaps they are chosen for their shape and tones, either similar or contrasting (figure 7.12) rather than their function and use. All the elements may be manmade, or natural, or all of the same period or relating to a particular craft or sport. Another more sophisticated approach is to pick objects through which you can express a *concept*, such as delicacy, tension, time, weight etc.

Choose your background carefully. Will it complement the main subjects and yet harmonise with them? Instead of plain card, consider using something with more character—textured wood or fabric perhaps. Your choice of tone or colour can alter the apparent contrast of the picture.

At the same time it could be a mis-

7.12 Still life group—objects chosen for their contrasting shapes and textures.

7.13–14 Background patterns which merge
with the main subject give a confusing result.
Use something with a complementary tone,
pattern or texture.

take to let the background dominate and distract, like figure 7.13. Some photographers start by setting up the empty background, focusing and looking through the camera while they position each item in turn as it might be sketched onto a canvas. Alternatively, you can arrange and light the whole set by eye as best you can, then introduce the camera and make final adjustments to the composition.

Try to keep your still life as simple as possible. If it contains many diverse objects try to unify them—by line, colour and shading—to harmonise both in internal detail and the shape of the group as a whole. You can compose for tension or tranquillity. Remember that hard shadows, often the best way to emphasise a relief surface, may complicate and confuse a group of three-dimensional objects. Generally the more varied the surfaces to be lit the softer your lighting should be. It does not however have to be frontal and flat. Soft directional lighting from a large source is excellent for smooth curved surfaces such as apples, pears, peppers, glazed ceramics, dark glass bottles etc., as it also gives a long thin highlight which also helps to delineate shape and form. Subjects with highly reflective surfaces such as polished metal may have to be closely surrounded with tracing paper or muslin so that all lighting is strongly diffused. Transparent glass objects often look best when backlit.

Notice that even straightforward record photographs of machinery etc all benefit from the same care and approach of the considered still life. A good photographer pays extraordinary attention to detail over a cookery illustration or, say, a picture of a chilled can of drink. Don't overlook the use of technical controls such as camera movements.

Often a composition is strengthened and simplified by moving so close that the subject itself fills the entire frame. This avoids background problems and helps to isolate detail. Just bear in mind that close-ups greatly reduce depth of field.

Experimental

Half the fun of having a studio is that it allows you to experiment. What happens for example if you get your sitter to move during a short time exposure...e.g. change expression,

rotate or nod the head, swing the whole body? Using a dark background you can set up studio lamps either side and get your subject to dance to music, do exercises, juggle etc. (figure 7.1). Try to arrange aperture and light intensity so that you give an exposure time of around $\frac{1}{2}$–3 sec. Fire a flash as well during the period the shutter is open, and you can add a frozen 'core' to all the blur. Adjust distance to suit the f number in use. You can shoot on daylight colour film so that the frozen part is correct colour and the blur appears orange. Also try writing in light, see page 85.

Fitting different coloured filters in front of your lights allows you to make highlights one colour, shadows another. On the whole, with more than one colour, pale filters are more effective than strong ones. It may help to keep one light source unfiltered so that some part of the figure or background appears in normal colours. There are also great possibilities in using one or more slide projectors to throw actual images onto the subject or background—with or without other studio lighting. This is discussed in more detail, along with other special techniques, in the next chapter.

PROJECTS

P7.1 Find examples of studio portraits by at least *two* of the following photographers: Cecil Beaton; Richard Avedon; Yousef Karsh; Philip Halsman. How does their work compare in terms of lighting, use of background and setting, and control of sitter? (You can often tell the number and type of lights used by closely examining highlights shown in the eyes.)

P7.2 Take two portraits of the same model with illumination arranged to give (1) a low key effect, the result portraying a quiet pensive mood; and (2) an effect of brilliance and a portrayal of liveliness. Make similar size prints and mount for comparison.

P7.3 Choose an appropriate model and produce a sequence of monochrome photographs, *either* (a) frontal and profile character studies; or (b) a collage of at least six studies of expressions; or (c) abstractions of individual facial elements.

P7.4 Take a formal head and shoulders portrait of a model in the studio using one lamp and a reflector to give a three-dimensional effect. Using similar but natural lighting take a second photograph of the same model in a location which portrays him or her identified with some form of activity.

P7.5 Produce two still-life photographs in colour (1) a group of manmade forms, and (2) a group of natural forms. In each case choose objects which relate in colour or texture.

P7.6 Using numerous pencils, chalks, crayons or felt pens as subject matter create a colour photograph having a strong graphic design, suitable as a poster for a drawing materials exhibition.

P7.7 Using studio lighting take three photographs of unglazed pottery; (1) a pleasing arrangement of a group of three pieces; (2) a single piece, accentuating its shape; (3) an interesting detail, with emphasis on surface texture.

QUESTIONS

Q7.1 Describe the characteristics of a subject you would select and the operating method you would adopt to produce a high key colour photograph.

Q7.2 Explain in detail a lighting set using two flash-heads to take a portrait to give good modelling to the features. Illustrate your answer with a diagram showing the relative positions of subject, camera and lighting.

8. Special Techniques

This chapter suggests ways to modify the normal photographic image. Some techniques rely on camera work while others are darkroom or workroom based, so you can manipulate pictures already taken. Variations in subject, technique and individual imagination allow you plenty of scope for unusual results. Consider the examples here as starting points—useful for creating an 'impossible' situation, or for attracting the eye and strengthening the statement your picture is trying to make.

Projected images

Slide projectors make it easy to combine two images, or an image and object, as shown below. The lamp colour of most machines suits 3200K film—but check by comparing it with

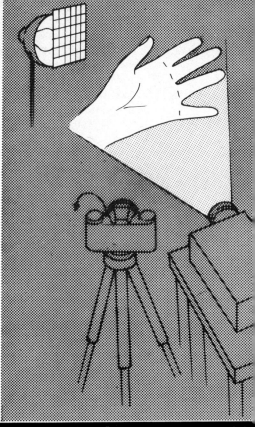

8.1–2 Below: A colour slide of brickwork projected onto a real hand. Right: The studio set-up.

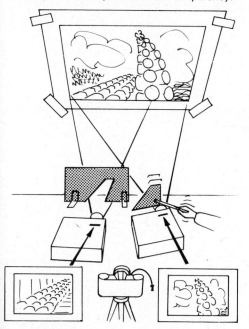

8.3–4 Strange things happen when you combine images from two projectors, and copy the result. Below: Two shaders were used to block unwanted parts of each transparency.

studio lighting. Colour transparencies, black and white negatives etc can be focused on to any light toned three dimensional surfaces (e.g. eggs, paper cups) in a darkened studio. You can help to give form to the object itself with a masked down flood directed from the side or rear, but this must not over-power the projected image.

You can also use twin projectors to montage transparencies. Project the two images onto a matt screen such as a large mounting card, then copy the montage using a camera, long focus lens and tripod from behind the machines. See figure 8.4. Measure exposure as if copying a print. You can remove unwanted bits from each image by shading the light beams during exposure, rather like enlarging. Keep your shaders on the move. A neutral density filter will dim one image relative to the other, and you can alter size relationships by zooming one projector or changing its screen distance.

8.5 A mosaic type panorama, a contact sheet printed from carefully planned exposures on one complete 35 mm film. Always photograph from top left to bottom right.

Panoramas

You can make an accurate-looking panoramic view by taking a picture series from one camera position, overlapping the contents of each frame by at least 50%. Make matched prints using the central zone only of each picture; Cut along convenient lines (e.g.

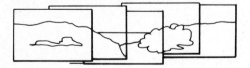

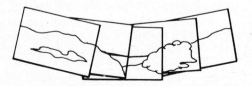

the side of buildings) and mount them as a mosaic. Shoot with a long focus rather than wide angle lens, avoid detailed foregrounds (near objects do not join up accurately) and choose consistent lighting conditions. Keep the lens axis horizontal—a slightly downward or upward looking camera gives a panorama with a convex or concave horizon, figure 8.6.

Another approach is to abandon strict accuracy and aim for a mosaic suggesting general appearance. Figure 8.5 uses each film frame like a window pane. You need to pre-plan how many exposures are required per row. Don't overlap pictures—compose allowing gaps for the divisions between frames.

8.6 Left: A five exposure panorama taken with the camera dead level. If the camera is tilted pictures will only join up in a curve.

Lens attachments

Attachments to modify the image fit all cameras but are ideally used on a single lens reflex where you can see exact results, check effects of stopping down etc. A soft focus lens attachment overlays a sharp image with one which is slightly hazy and diffused. Highlights are enlarged and spread, giving a delicate, nebulous effect with weakened colours and reduced contrast. A diffuser has a similar effect but results lack the 'core' of underlying fine detail preserved by true soft focus. For localised diffusion (e.g. flattening and merging of detail in areas which distract from the main subject) try smearing petroleum jelly on a glass UV filter, leaving, say, the centre clear. Check the effect on the image at your working aperture. The radiating blur lines shown below are made with a zoom (variable focal length) camera lens. You set the shutter on about 1/8 sec or slower, then sharply change the zoom setting during exposure. Lines radiate from the very centre, so make sure this is where you place your main element.

If half your picture contents are very close to the camera and the remainder far away, a semi-circular close-up lens may render them both sharp, even at wide apertures. Looking carefully at the picture bottom left you can just see the shift-of-focus line across the road and hedge, caused by the half lens. Hide the change with some plain zone or edge in the subject.

Experiment too with the facetted glass or 'prism' attachments which give you either three, four, or five overlapping images. These are good for

8.7–8 Special effects. (Top pair) Diffusion by a greased U-V filter, and zoom lens zoomed during exposure.

8.9–10 (Bottom pair) Effect of using half-lens close-up attachment, and triple image prism attachment.

dreamlike pictures and unusual graphic designs; choose a simple subject against a plain background.

Infra-red Ektachrome

This 'false colour' 35 mm transparency film was originally designed for aerial photography. Its three emulsions effectively respond to green, red, and infra-red, giving yellow, magenta and cyan dye images respectively. You expose the film in daylight or with flash, using a deep yellow filter, then give normal Ektachrome processing. Results are often startling and bizarre. Living green vegetation containing chlorophyl appears bright magenta or scarlet (particularly young growth lit by direct sunlight). Lips, flowers and most red paintwork or clothing reproduce yellow. Flesh appears waxy, eyes black, and blonde hair goes grey. Skies remain blue, and stonework, pavements etc have a bluish tinge.

If you use a deep green filter instead of yellow, most scenes simplify to rich blue and magenta (see figure 5.13 on page 57). A deep red filter gives a strong overall yellow result, and no filter at all gives a dull, rather blue effect. Bearing these transformations in mind, you can seek out an interesting picture from simple tufts of grass, fields and woodlands or an urban city street scene.

This is a good way of taking a new look at over-familiar objects, and creating a fantasy world. The film is rather contrasty, so avoid harsh side or backlighting and make really accurate exposure readings, 'bracketing' where possible.

8.11 A red rose, a human hand and a privet hedge as recorded on infra-red Ektachrome. Film was exposed through a deep yellow filter.

8.12 Right: Drawing with light, using a sparkler in a darkened studio. (Frank Thurston).

Drawing with light

You can write or draw designs in light, using an area of darkened studio, or working outdoors at night. Have the camera on a tripod. Position two white objects to show you the left and right limits of the lens field of view. Your 'performance' must not exceed these extremes. Focus on a hand torch held midway between the markers and set the shutter for 'B'. Now stand between markers wearing dark clothing and keep the torch pointed towards the open lens, while you move it at a steady writing speed. Lettering etc will photograph laterally reversed, so you must finally project or print through the *back* of the film.

Torches with built-in filters allow line colour changes, or you can organise someone to use a series of filters over the lens (have a neutral density filter for white lines, to keep exposure consistent throughout). Hand fire-

works such as sparklers make good 'light pens'. Exposure varies according to strength of light and speed of drawing. Test at about *f* 16 (125 ASA film) for a total writing time of about 10 sec.

Another way of creating 'drawn' light patterns is to move the camera about with the shutter open at night.

8.13 (Below) Patterns formed by moving the camera around with its shutter open in a city street at night. Exposure 15 secs at f16.

8.14 White carpet becomes fantasy landscape. Double printed from two negatives onto one piece of bromide paper.

Double printing (black and white)

Double or combination printing means enlarging two (or more) images onto the same sheet of bromide paper. This allows you to combine picture elements taken at different times and in different places, altering relative sizes and juxtapositions. Figures can be printed in, and buildings re-structured or multiplied in number. The aim may be a naturalistic effect, as when adding silhouette shapes to a foreground to increase aerial perspective. Or you may want to create impossible situations like figure 8.14. Photography is such a realistic medium it produces very convincing untruths. Double printing, like cut-and-stick montage (page 94) is therefore an excellent way of constructing surrealistic compositions.

You might work from bits of existing negatives, but if possible plan the picture as a whole, then photograph each component so that lighting, perspective, negative contrast etc are exactly what you need. In the darkroom enlarge up the first negative and trace the area you intend to use onto drawing paper for future reference. Test and expose two or three prints, shading unwanted areas continuously with black shaped card or your hand (keep it moving to blur the edge line). Mark the back of the bromide paper to indicate the top of the picture.

Now set up the second negative, adjusting size and position to marry up with the reference drawing. Test and expose onto one of the previously exposed sheets, shading unwanted parts of the new image component, and overlapping it slightly so that old and new merge.

Bas-relief

In a bas-relief ('low relief') photograph normal perspective is replaced by a shallow depth image, looking like embossed paper lit from one side. Compare figure 8.16 with the conventional print on page 100.

Basically you use negative and positive images on film, sandwiched together but set slightly out of register. Photograph (or copy an existing bromide print) choosing a subject which has strong linear elements, and is rendered sharp throughout. (Photograms made onto sheet 4 × 5 in film are also suitable.) Having made a negative contact print this onto a sheet of ordinary film, to get a positive image. Both negative and positive should be full of detail but low in contrast with no tone stronger than dark grey, so overexpose and underdevelop.

Next register the two films emulsion to emulsion, and shift one sideways *slightly* so the displaced images form narrow dark and light lines. Hold the film sandwich between glasses and enlarge. The picture below was made from the images almost matching in tone range; for the version top right the positive was weaker than the negative, giving the final result a positive bias.

8.15–16 Two versions of bas-relief, made from overlapped negative and positive images.

Solarisation

This technique (strictly Sabattier effect or 'pseudo-solarisation'), is based on fogging to light during development. It gives a part negative/part positive as shown left, with an edge line following the boundaries of strong light and dark tones. Compare this with the original on page 77.

Work from an existing negative having plenty of detail and interesting important shapes. The image should be sharp and evenly lit throughout. You can expose a print normally on single-weight paper, then three-quarters of the way through development briefly switch on the white light. Complete the development time, without agitation. At the boundaries of image-exposed areas and light-fogged areas exhausted developer forms a line of lighter density. Fix, wash and dry the black looking print and then contact print it onto hard grade paper.

For better quality results contact print your basic negative onto 4 × 5 in line film (there is room to solarize six 35-mm negatives at a time this way). After half the normal time in print developer, place the dish *under the enlarger* and repeat the same exposure time, fogging the film. Complete development etc, and check results. For solarization as seen top right, adjust the printing and fogging exposure times until they both give similar tones of dark grey. Then cut these strips of dense 35 mm images from the sheet and enlarge each onto bromide paper. Note that each edge line is black.

For results with white edge lines (figure 8.17 opposite) conventionally contact print the solarized film onto another sheet of line film and make your enlargement from this.

8.17–19 Top right: Enlarged direct from a solarised print on line film. Opposite: This version had less fogging and was re-contact printed onto film before enlarging, as shown right.

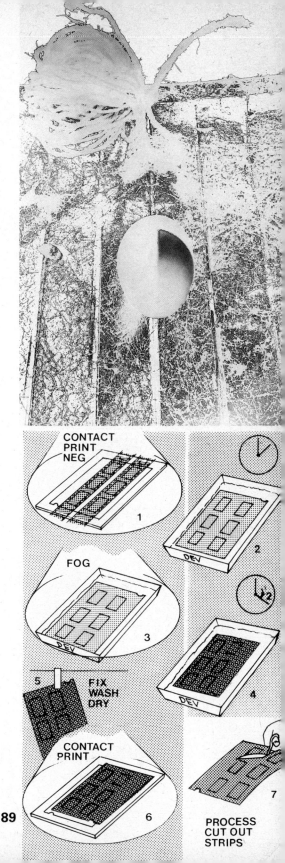

CONTACT PRINT NEG 1

DEV 2

FOG DEV 3

DEV 4

5 FIX WASH DRY

CONTACT PRINT 6

7 PROCESS CUT OUT STRIPS

Tone separation

Tone separation, or 'posterisation', changes a normal tone range photograph into an image consisting of a limited number of tonal steps. Each tone fills a set area, like a design worked in poster paints or silk-screened. Notice how detail is simplified and highlights and shadows exaggerated.

Start with a normal full tone range negative—preferably with a sharp, simple image. This is printed onto extreme contrast Kodalith film, processed in lith developer—commonly 2–3 sheets. Under expose the first sheet, so only darkest subject shadows record (black), and the rest of the film is clear. You give the second sheet sufficient exposure for shadows *and* darker mid-tones to record black. If you use a third sheet overexpose so the image is black except for bright highlights.

Dry off these tone separation positives, then print them one at a time onto a single sheet of normal contrast film. Use one separation to test the exposure needed to give a pale grey tone when the film is given normal negative development. Give this same exposure time as each separation is printed, in register, onto the film. After processing and drying enlarge the resulting final negative normally. You control the number of tones in a posterised image by the number of separations you make—two separations

8.20–22 (Above) Straight print from the original negative, and two prints made on lith film given under and over exposures.

8.23 Registering device (1) Negative attached to punched film tab. (2) Board with pins. (3) Printing onto lith film. (4) Printing lith separations in turn onto final film.

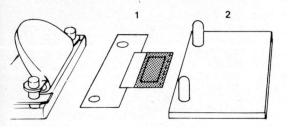

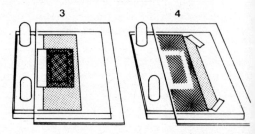

8.24 *The final posterised image consisting of black, one grey, and white.*

give one grey tone, three separations give two, and so on.

A convenient registering method is shown left. Start by firmly taping your original negative to a scrap half of 5 × 4 film having two holes made by an office punch. Glue two short 6 mm diameter pieces of wooden dowling onto black painted hardboard. In the darkroom punch each 4 × 5 in.

sheet of lith film, then slip a piece of this film and the negative over the wooden pins and cover the image area with glass each time you contact print. To print down the separations first tape down the unexposed sheet of normal contrast film to the board. Then each separation is simply slipped over the pins in turn, covered with glass and exposed. See also page 125.

Sandwiched and 'flashed' transparencies

'Sandwiching' means simply mounting two film images in the same transparency mount so that, when projected, the details of one appear in the lighter parts of the other. Both transparencies must have quite light toned images—e.g. be overexposed by at least one stop (reject frames?). Sometimes one existing transparency suggests another which needs special taking to complete an idea. Remember you can copy from magazines, posters etc. Be careful with your camera work—transparencies are difficult to adjust after shooting.

Also try combining black and white and colour versions of the same image. The former can be an underexposed negative, contact printed from the transparency. When bound together this turns all the image whites grey. For extreme effects make a negative or positive on lith film. Figure 8.27 is a combination of colour transparency and slightly underexposed lith film negative contact printed from it direct. You can also produce bas-relief effects by offsetting the two pieces of film.

'Flashing to light' (figure 8.26) is used for tinting the shadows of a colour photograph. Underexpose the basic image about one stop. Re-set your shutter without winding on the film (usually by holding in the rewind button, but check your camera instructions). Now fill the frame with even, suitably coloured light by moving close to grass, paintwork etc., rendered extremely out of focus. Measure and underexpose this by at least two stops. Colour flashing works best with contrasty subjects—the fogging light affects mostly the shadows and so has an image-flattening effect.

8.25–27 Left: A 'sandwich' of two over-exposed (weak) transparencies gives an un-real perspective effect. Top right: A silhouette image double exposed ('flashed') to bright blue paper. Right: Sandwiched colour transparency and a contact-printed lith negative.

93

Montage

You can construct a picture from various paper prints arranged so that they join, overlap or blend with each other. A montage can combine events which did not in fact occur together, e.g. in a group photograph someone with their eyes closed can be replaced by a cut-out print of the same person from the next negative, which is bad of everyone else. Similarly in landscapes a strong foreground lead-in can be combined with a distant main subject when in actuality they were hundreds of miles apart and shot on different days.

Montage allows surrealistic images—juxtapositions of unexpected objects or themes in a fantasy atmosphere. The effect may be simple like figure 8.30 opposite which makes a statement on objects in frames, or very elaborate like figure 6.8 on page 68. You can also montage patterns from several prints made from the same negative—through the front, through the back and (via an intermediate positive) in various negative versions. They are then butt mounted to form a long frieze, or patchworked into a kaleidoscope type pattern. Even a single print

8.28–29 Cut and stick. Left: A sliced and reassembled print. Below: Prints from two negatives (one printed through the back) butt-mounted.

8.30 A surrealist effect by simple print montage.

can be dissected into a regular pattern of slices, concentric discs, squares etc, which are then reassembled in some slightly different way, see opposite.

Prints for montaging should be made on single weight paper, preferably matt surface which is easier to retouch. Make your print as large as possible—by copying the finished work and printing say half size, cut edges and retouching will be reduced too. Prints should have a good tone range but be about one grade soft.

This allows for slight contrast increase when copying. Be careful that elements printed from several negatives all match in contrast and evenness.

In most cases the main background print can be mounted on board first. Cut out the other prints using really sharp scissors or a scalpel blade. You can reduce edge thickness by fine sandpapering the back of each print, then attach prints to the background with an even layer of adhesive such as rubber mountant, or aerosol gum.

Hand colouring

Not all colour photographs require the use of colour film. Hand tinting monochrome prints is interesting and even offers some positive advantages. You can completely control the colour of every element in the picture. Some parts may remain uncoloured and suppressed, others picked out strongly and emphasised, irrespective of original appearance. In fact it is best not to aim for complete realism but work according to the mood of the picture.

Start with a paper print (after colouring this can be copied on colour film if you want the result to be a transparency).

The print should be fairly light because underlying dark tones desaturate your colours. For similar reasons it helps to sepia tone the image before colouring. See formula, page 121. Choose matt, not glossy paper—its extra gelatin often gives uneven results. Remember too that big prints take longer to colour than small ones. Choose a size you know you can finish.

Use either transparent 'Photo-tint' dyes or water colours. Dyes give stronger hues (you can build them up by repeated application), but unlike water colours mistakes cannot be washed off. Mount the print for colouring and slightly dampen its surface to swell the gelatin. Start off with the largest areas, applying a colour wash on cottonwool. Medium and small areas are best coloured by brush (size 0-4).

When colouring all but one area of a print you can paint this part over with waterproof Strip-mask. An even colour wash is then applied overall, and the rubber skin peeled off later, leaving the protected part uncoloured and with a clean outline.

8.31 Hand-tinted black and white print. This allows greatest freedom to choose and limit your colours. (Sue Wilks)

Summing up

Special techniques can be fascinating—too fascinating. Not every photograph is improved by manipulation, and you can waste time nursing along a weak and unsuitable image. So start off with an idea, then shoot your basic picture, and manipulate if it expresses your idea more strongly and simply.

PROJECTS

P8.1 Using colour transparency film make either a sequence panorama using five consecutive frames, or a complete four-by-five frames mosaic. See figure 8.5. Lay out your strip(s) of processed film between 10 × 8 inch sheets of acetate.

P8.2 Produce a portrait in pure black and white, suitable for a school magazine cover. Use soft, frontal lighting when shooting, and expose on normal contrast film. Make a good quality bromide print and copy this onto line or lith film. (Control exposure carefully—this determines which greys become black, and which white.) Finally print onto hard paper.

P8.3 Look at examples of the graphic work of M. C. Escher. Construct a picture by montage in which you 're-design' some local architecture. Consider using prints made through the front and back of negatives.

P8.4 Use a slide projector to form an image onto a three dimensional object, and shoot three black and white or colour photographs on the theme 'Odd Man Out'.

P8.5 Make a head and shoulders profile portrait. Produce a print which resembles a medallion in low relief.

P8.6 Make a statement about people and their environment in your area, using *either* double printing, or montage, or sandwiched transparencies.

P8.7 Produce a hand-coloured print on one of the following themes: Emergency; Food for the Gods; The Enchanted Garden.

P8.8 Machinery often has a characteristic regularity of form. Produce four different monochrome images of machinery, and from these create an abstract design using combination printing and/or photographic montage.

QUESTIONS

Q8.1 Describe two photographic printing techniques producing results which differ radically from factual representation. Explain briefly why these techniques may give greater visual impact and aesthetic appeal.

Q8.2 Colour transparency images can be combined by (a) sandwiching and (b) superimposed multi-projection. Explain the differences between the types of final result made possible by each techniqe.

8.32 Line image version of figure 1.14 produced by copying a normal print on lith film, then printing onto hard paper.

9. Working to Themes

One of the best ways to discipline your photography is to work to a particular topic or theme—something chosen yourself, or perhaps set in a competition or examination. This challenges you to organise ideas and plan your approach. Some themes place greatest emphasis on picture content, some on picture structure, and the underlying concepts and ideas. In documentary projects such as 'A Day in The Life of...' the picture content (what is going on) is of first importance. The function of your picture or pictures is to narrate a story or describe an event, or help explain a situation. A theme such as 'Depth' or 'Flow' is more of a challenge in design, structure, and the special qualities of the photographic image.

Another division occurs between themes which can be distilled into one picture, a pair, or a sequence. A single picture may be the most direct way to sum up a simple concept such as joy or sorrow, or a quality such as texture or pattern. Comparisons too can be made if the one image divides naturally into compartments. Two separate photographs offer much greater freedom for making comparisons and contrasts. Similarities (such as background, lighting, size of image etc) in both pictures will all help to show up differences in the main subjects. A series of, say, 4–6 pictures gives still more scope—you have time to tell a story or explain a process, show changes of time and place, develop a theme. Moreover, you can give emphasis at particular points, e.g. by careful choice of print size and layout.

On the other hand, the use of several pictures can dilute and fragment your ideas if they lack *continuity*. Try creating links, perhaps through subject relationships; through the use of similar picture structure (shapes, composition); through story-telling (a strong narrative thread); and by a well laid out final presentation.

Deciding the theme

Portrait themes. Think of all the ways you can plan to show an individual—at work, at home amongst his or her possessions, with the family, travelling, relaxing, or practising a hobby. Compare the public face and the private reality. All this demands patience and time to get to know your subject well, really observing physical appearance and mannerisms, seeking out visually interesting, representative aspects of their life.

Another way of working is to make a series of different portraits which when put together forms one group, e.g. a photograph of every family in the street, each at their own front door. (You could use the same camera distance, lighting, and final print size to give continuity.) Let each collection of people group themselves. You can even show their reactions to being photographed—some posing and showing off, others shy.

Try photographing all the members of one family separately at their various homes and finally all together at a party. Edit your pictures so that the family likeness forms one thread of continuity.

Structural themes. The main element here may simply be pattern, movement, colour etc. Try making a series having a common colour scheme, such as the blue theme opposite. Challenge yourself to discover suitable subjects offering many variations in content, tint and shade, while preserving a chosen hue. Incorrect colour lighting, filters, coloured reflectors, and over or under-exposure can all be used if these contribute interesting variations. Aim

9.1–8 A theme simply based on seeking out and using one colour.

9.9 Part of a documentary series on the town of Reading. Differing print sizes give variety.

to make each shot a complete, satisfying image within itself too.

A black and white project on the theme 'light' might begin by thinking about all the subject qualities—brilliance, refraction, shadow casting, reflection, etc—you consider important. Take time over this, noting the effect of light on various forms and surfaces, under different atmospheric conditions. Then work through your list, eliminating similarities and distilling down about a dozen characteristics you want to show (these can be further edited after shooting). Now find suitable subjects and techniques to communicate each aspect, e.g. reflected sunlight glaring from one window in an office block, or long shadows of people and cars.

Don't overlook the macro world, and also try using appropriate lens accessories such as a hair-line filter, prism attachment or diffuser. Remember that coarse grain film printed hard can give a gritty edge to intense highlights, increasing the feeling of irradiation and brilliance.

Narrative/documentary themes. Typical story orientated themes include 'The Kite that Escaped', 'Joe's Day on the River', etc., the more documentary 'Hot-Rod Scramble', or something based on a local industry.

Don't just put together six dull, visually unrelated pictures of a church, post office, Town Hall, and school, and hopefully call it, say 'A Portrait of The Town'. Plan your pictures in advance. What are your impressions of its people, industry, trade, leisure activities? Consciously seek out picture links formed by similar or complementary shapes, use of foregrounds, com-

mon colour schemes etc. Small things count too. If you feel the town is oppressed with notices and signs each photograph might contain some kind of notice, or one image could be crowded out with them (use a long focus lens from a distance, or even use montage). If the town's major geographical feature is a steel works or cathedral spire let this dominate the horizon of almost every view.

The story or narrative thread could just be passage of time (throughout a day, or year) or a journey from one place to another. Most series also need visual *variety*. Start off with an interesting establishing shot—a strong general view setting the scene—then move in to concentrate on particular areas, including close-ups and lively, unusual viewpoints. The final picture is even more important than the first. It might

bring the viewer full circle, e.g. the opening picture reshot at dusk.

'Actuality' reportage projects include themes such as documenting a trade or profession; or making a social statement about how people live and react to their conditions; or reporting an event. Things are happening in front of the camera, hopefully without manipulation from the photographer. Your job is therefore to be in the right place at the right time, and be quick thinking enough to capture events as they occur.

For the broader documentary themes it is seldom possible to give in-depth coverage from a single visit. Get to know the person, subject, or area so that you can develop an informed point of view. This way your pictures will have something to say.

Always look behind the scenes. In

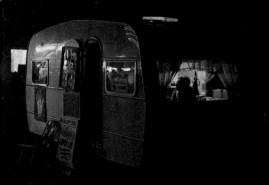

a series on a market, for example, it could be important to show traders arriving and setting up stalls and barrows; their relationship with the police and other authorities; where they brew up their tea and have their lunch; what happens when it rains; how they decide prices or deal with complaints; what happens to left over stock at the end of the day, and so on.

Comparisons—humorous, sad, sentimental—are your strongest devices. One person's way of life can be contrasted with another—eating, travelling, or at work. Sometimes comparative pictures can be designed with similar structure and shapes, subtly reinforcing the points you are making. Remember too how just including two elements in the same picture makes them appear to be related (figure 9.10). Since documentary photography is mostly impromptu and on the spot, be prepared to shoot a large number of exposures. Even professionals expect to discard far more pictures than they finally use. The images can later be cropped and numbers edited down with due regard to continuity, variety and strongest coverage of the points you need to make.

9.10 Top left: Creating false relationships. From this viewpoint the lone bather appears to relate to figures on a distant promenade. He seems about to perform some great feat.

Conceptual themes. The most challenging, interpretative types of theme deal with concepts and intangibles, 'Harmony', 'Discovery' or 'Joy' etc. Ideas are usually more important than subject because such topics are so open-ended. A theme such as 'transformation' could be tackled with an objective, natural history sequence of the tadpole-into-frog kind...or a set of photograms in which abstract shapes change and merge. It could deal with a series of derivations from one basic image, or the way a landscape alters with lighting, changes of season etc. You could even attempt it in one picture, using the hands of a young child and an elderly person.

A series on flow might use the underleaf structure of a cabbage in close-up, blurred movement of a stream around a rock, the form of a human hand, or light tracery created at a firework display. All the foregoing could be treated in a boring, obvious way by one photographer, or turned into something visually exciting by another. Take time to think out the possibilities offered by the theme. Learn from your own photography and from work published in books and magazines. See page 122.

Often the strongest pictures leave something to the imagination. Perhaps they can be read on two levels like the door series below, which has a direct visual appeal in its contrasting colours and designs, but also leaves you wondering what the families who live in each house are like. Figure 5.1 on page 52 has a direct impact and appeal but virtually says everything at one go. Pictures which have some ambiguity— however slight—you can keep returning to and still discover something new.

Presentation

Even when planning or shooting, try to visualise the way your picture will finally be presented. Five or six pictures together on one large mount offer opportunities and limitations quite different to one picture per page in a photograph album or magazine. Each mount or album 'spread' should present a balanced design, yet give variety, e.g. through the size and distribution of main and supporting pictures. A large mount is like the wall of a gallery in miniature, and gives scope for 'hanging' your set of prints in all sorts of ways. Try to vary the proportions of your pictures to really suit their in-

9.11 Left: A documentary picture which shows an outside/inside situation simply and well.

9.12 Below: A series on doors can be planned and presented to create your own complete, made-up street.

dividual content and structure. This also gives variety. On the other hand, complete uniformity of size, shape, and layout can be useful as a continuity device too (figure 9.12).

Consider the tone of the mount carefully. Grey has least effect. White contrasts with low key pictures, and any dark objects cut by the picture edges have an amputated appearance. Black mounts have the opposite effect, emphasising highlights and white shapes along picture edges. You can hold together various awkward shapes by enclosing the picture within a thin frame line. Butt mounted prints are useful if you want your set seen as one continuous image or pattern. Captions under photographs, although sometimes necessary, are often there to patch up weakness in the pictures themselves.

Colour slides are rather special. If you use a projector to show one after the other in a darkened room the effect is like turning the pages of a black-leaved album, one picture of identical size to every page. This is fine for single images or consecutive pairs, but long sequences can become monotonous unless dissolve projectors are used. Dissolve projection and the use of sound is discussed in the next chapter.

PROJECTS

P9.1 Make a series of five monochrome photographs to illustrate one of the following relationships, stressing their interdependence: (a) people and animals; or (b) people and buildings; or (c) people and machines. Use variation of print size to produce a balanced layout.

P9.2 Take four portraits in which the subjects all have some feature in common (e.g. all of an age, with glasses, in uniform etc.). Show the common factor but stress the individuality of each person.

P9.3 Compare the portrayal of city life by any two of the following photographers: Lee Friedlander, Bruce Davidson, Henri Cartier-Bresson. What is each photographer most interested in and trying to show through his pictures?

P9.4 Using hands as an expression of emotion, produce three pictures, each conveying *one* of the following—anger, tenderness, tension, prayer.

P9.5 Illustrate three of the following themes, using a pair of pictures in each case: simple/complex, young/old, tall/short, hard/soft.

P9.6 Make twelve black and white exposures on *one* of the following subjects: wheels; doorsteps; shadow patterns. Contact print your negatives and enlarge the best four.

P9.7 Make a documentary series of four monochrome pictures on either 'Children at Play', or 'Shopping', or 'A Day Off'.

QUESTIONS

Q9.1 The comment 'the camera does not lie' is frequently heard. Discuss this statement, giving examples to support your views, and compare the nature of the camera image with that received by the eye.

Q9.2 Discuss the various ways in which *continuity* might be achieved when producing a picture sequence based on a particular theme.

10. Slides Plus Tape

Projected slides accompanied by tape recorded music, sound effects or the spoken word allow all sorts of extra creative possibilities. Even just adding suitable music to one of your existing slide series immediately helps continuity and improves presentation. It is possible to make sound documentaries, dramatic stories, visual interpretations of music etc. Better still, with a *pair* of projectors you can achieve dissolves and other special effects. The results can be similar to sound movies—but cheaper and with much better image quality.

Dissolve projection equipment

A few special single unit dissolve projectors are made, but you will probably have to use two normal magazine slide projectors with some form of fading device. The home-made arrangement below uses two shaped pieces of plywood sliding in plastic channelling. Moving the lever by hand 'stops down' one lens and 'opens up' the other. (Devices such as this must operate close to the lens, otherwise the dimming or brightening of the image will be uneven across the picture.) A much better but more expensive system is to use a pair of suitably designed projectors, linked to a control unit which dims the lamp in one projector and brightens the other.

10.1 *Projector dissolve units. Left: A low cost home-made device. Right: An electrical variable dissolve, with hand control unit.*

Whatever the system—mechanical or electrical—both projectors are set up and focused on the same area of screen. Operating the dissolve makes the image seen on the screen gradually change from one picture to the next. As soon as one projector has blacked out completely its slide is changed, making it all ready to fade up with a new image. An electrical dissolve unit generally allows you to choose dissolves or 'snap' changes.

The recorded sound to accompany your dissolve slide sequence can be replayed from an ordinary tape recorder, while you manually operate the dissolve unit to relate to the sound track. Most electronic dissolve units have a built-in tape cassette deck and loudspeaker for playing your tape. As you arrange your program the signals controlling fast or slow dissolves can be recorded onto a second track on the tape. So when you re-run the cassette both the sound record, music and speech (heard from the loudspeakers) and dissolve commands (played out only to the projectors) give a fully synchronised presentation.

Dissolve projection possibilities

Being able to dissolve smoothly one image onto the next means you can produce a degree of action or movement on the screen. The highlights and

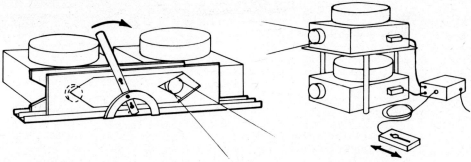

lighter areas of the fading-up image appear first, most noticeably in the darker parts of the image being faded down. Gradually the new image takes over, the last parts of the old one to disappear being its highlights, particularly where these coincide with dark areas of new picture.

So, throughout the dissolve, the image on the screen is constantly changing, being a mixture of the two slides in ever-changing proportions. This offers plenty of visual possibilities, some of which are shown on the right. If each slide in a series shows exactly the same scene, then dissolving from one to the other will not be detectable on the screen (assuming the images are registered properly). But if one element in the picture changes position this appears to dissolve and shift against static surroundings.

You can photograph someone sitting on the floor, then *without moving the camera* (have it on a firm tripod) take another picture without the sitter there. Projecting the first frame and then dissolving into the second makes your figure fade away into the floorboards. Similarly a portrait can be made to change expression, frontal lighting change to side or silhouette lighting, and a street scene change from day to night. In all cases each slow dissolve takes you through a whole range of images (e.g. the street scene shows dusk gradually increasing, windows lighting up, etc.).

Figures can be moved around landscapes or, by carefully keeping the main subject the same size and position in each frame, you can transform surroundings only. Other possibilities include shift of focus from one object to another; progressively moving in closer; showing the steady growth of, say, a crystal under the microscope; changing colour filters; or transforming the subject from full colour into normal or high contrast black and white. Lettering, diagrams and drawings offer their own possibilities. You

10.2 When this series is dissolved from one frame to the next the figure 'melts' and appears to move within a static landscape. You must shoot with the camera on a tripod.

10.3 The same tree patiently photographed from a window during each of the four seasons of the year. Dissolve projection gives blossoming, then leaf fall appearance.

10.4 Lit by one spotlight changed to a different position for each exposure. Dissolving creates a wide range of intermediate lighting effects. Again image position must remain fixed throughout, so use a tripod.

10.5 A slow transition from dog to lion. The middle frame is a sandwich of two over-exposed transparencies. Try to keep the eyes in the same position in each frame.

can make a drawing appear bit by bit, a painting gradually fill in with colour, or a title fade into the opening picture of a sequence. Subtle transformations are possible between pictures having compositions similar in shape and structure but totally different in content.

Source of pictures

Most pictures for dissolve slide/tape presentations are of course colour transparencies of subjects you photograph yourself. But don't overlook other types and variations of image. For example, pictures or parts of pictures can be copied from magazines, books, postcards, or even off TV. Transparencies can be in monochrome—copied black and white bromide prints or original negatives, printed onto film. These might be sepia or colour toned, or hand coloured. Don't overlook photograms, made direct onto printing paper and copied onto film. Equally you might make and copy drawings or paintings, or patterns and shapes arranged from bits of coloured acetate, inks or dyes, laid out on glass or plastic and lit from beneath. You can even sandwich bits of transparent coloured materials between the slide mount glasses themselves, and so construct your own transparency.

For special effects, nightmare sequences etc, remember the possibilities of colour photography under sodium or mercury-vapour street lights, using a prism attachment or multi-coloured filter or, shooting on infra-red film. Your Ektachrome can even be developed as a colour negative.

Captions, titles and written matter of any kind is best prepared using transfer lettering or handwriting onto card. Remember to work within the 35 mm picture format ratio of 2:3. Then you photograph this to fill your 24 × 36 mm frame, using colour film or perhaps lith film. The latter gives a bold negative image—often more effective than black lettering on a white ground. To colour the lettering bind in a filter, or you can hand colour (white) lettering on the film, using phototints or a spirit based pen marker.

Sources of sound

The simplest kind of sound accompaniment to a slide sequence is generalised music which suits the mood of the pictures. This can enormously improve continuity and the general presentation of your sequence. For documentary and story-telling themes you can use spoken commentary, recorded interviews and sound effects. Music can be performed live and recorded, or recorded from radio or commercial discs or tape (this is normally acceptable provided your slide/tape is for showing privately).

Sound effects are fun to devise and record, or they can be re-recorded from sound effects records such as those sold by the BBC for home movie use. Select carefully and don't overdo them. On-the-spot interviews—people talking about their work, commenting on social conditions etc—can be recorded on a battery operated tape machine.

Recorders always pick up more background and extraneous noises than you noticed at the time. It's like shooting with a lens giving too much depth of field. You can reduce this by always holding the microphone within 30 cm (12 in) or so of the person talking, and using a wind muff outdoors. When recording a commentary for a finished picture sequence choose a small, quiet room with curtains and carpet to reduce reflected sound. You don't even need a projector—just hold each slide up to the light in turn as you speak, figure 10.8.

10.6 *A storyboard planned on postcards, one per frame. Cards can be regrouped for the most convenient order of shooting, and again for sound recording.*

Production step-by-step

First decide broadly what your slide/tape sequence is intended to do—inform, entertain, instruct etc. Will you be handling it all yourself or working in with a team, each person either photographing, or recording, or making arrangements, or copying and making titles etc? Either way, the best method of working is to plan it all on paper first, preparing a kind of script for pictures and sound before you commit anything to film or tape.

1. *Basic planning.* This is where everyone can chip in with ideas. If you are to tell a story is it to be picture based or sound based? (Sound based sequences start with a completed recording, say pop or classical music, to which pictures are added. This means timing each passage to deter-

mine the type and number of images required.) Will you use live action—either acted or shot as it actually happens? Or will you be working mostly with shapes, patterns, colour etc, mostly generated from still lifes, landscapes or even drawings or photograms?

How many locations/backgrounds will be needed? Roughly how many pictures are necessary to put over the information or story? The maximum number is limited by the capacity of the slide magazine: and programme *length* cannot be less than the number of pictures multiplied by the fastest slide change your projectors give (typically 3–4 sec), but you will want to vary the pace and rhythm to give variety too.

How much can you afford to spend

10.7 *The first twelve frames of a photo-play. The pictures dissolve into each other in the order shown. Compare with planned story-board figure 10.6.*

in film, tape and time? In general, assume that everything will take longer than you expect. And don't be too ambitious—particularly at first. Go for a simple idea which can actually be completed.

2. *Storyboard.* Having decided the topic and general story structure of your sequence you can get down to picture-by-picture planning. The most practical method is to use sheets marked out with frame rectangles, or separate postcards which can be arranged in sequence in a file or rack (figure 10.6). Here you roughly sketch

the content of each transparency and write alongside a brief note on the words or type of sound that will be heard from the tape. In general let the *picture* make the main statement, and the sound a supporting role. As a rough guide don't use more than 20–30 words per slide—or hold a slide on the screen for longer than 10–15 sec.

Begin to think about the use of distant, medium and close-up pictures, and whether to dissolve or snap change between each. Make a special note of tightly registered images, e.g.

action occurring against an 'unchanging' background.

Of course, if the sequence is entirely documentary, shot as an event occurs, you can only plan in outline at this stage. Still, you should devise some sort of idealised structure, which is helpful to remember during the photography and can be worked to in editing. This is the time too for deciding the format shape—vertical or horizontal—for your series. (Although the two may be mixed this can be irritating and works against continuity.)

3. *Shooting script.* This is really the storyboard appropriately marked up (or cards reshuffled) so that all the pictures to be taken at one location, or of one person, are grouped together. This avoids wasting time dodging about from place to place or keeping people waiting. Take care over the lighting and the inclusion of minor elements ('props'). Pictures exposed out of sequence and edited into correct order later must not show inconsistencies. At this stage you can also be taping your location sound—background noises, interviews etc. It is difficult to photograph and record at the same

10.8 Adding the sound to colour slides. 1: Recording the commentary. 2: Mixing voice and music to record the master tape. 3: If the unit allows, dissolve signals are recorded on the second tape track while listening to the first. The unit will then replay the whole show automatically.

time because equipment gets in the way, and you cannot concentrate on getting both good vision and sound. So if possible do your recording immediately before or after the camera work. Always tape far more than will actually be needed, so that you can pick out the best bits later (tape itself is inexpensive because it can be reused).

4. *Picture editing.* This is where some sort of light box—a sheet of opal plastic or glass set over a fluorescent tube—is really helpful. Lay out your processed slides and compare picture content, quality, and continuity. Remove doubles and spares, then divide the sequence into alternate piles for the two projectors and see how the images begin to look and relate on the

screen. At this point you will probably want to modify your original storyboard to accommodate good unexpected pictures, and allow for others which proved impossible to shoot. While you are previewing in this way read over any existing commentary or, if the project is an on-the-spot documentary, sketch out how much spoken material is needed and where it should come. You will probably need to subtract or add slides from your stock of spares to allow the right number of pictures for your sound. You may have to reshoot an essential but unsatisfactory frame, create special effects by sandwiching transparencies, and so on.

If the slides are just in simple card holders remount your chosen sequence into glass faced plastic mounts. Each

piece of film should be positioned and framed up in exactly the same way in each mount.

5. *The sound track.* Of course, if your project has been to illustrate an existing piece of music all you need now is a straight recording—the pictures being edited and timed to the sound. If pictures are being accompanied by a recorded interview it will be best to edit the sound first (by re-recording, leaving out the pauses and irrelevant bits) then fit pictures to suit this length of sound. But in most cases you will want to prepare sound—background effects, commentary, music—to suit your picture sequence. With help you can 'perform' the whole track while looking at the slides. Have someone ready to turn up the record player or prerecorded tape machine during the right gaps in your spoken comments. Or (figure 10.8) you can record your commentary, leaving gaps, then feed this plus music or any other recordings through a mixing unit onto a new, final tape to suit slide timings. This has the advantage of exact control over sound balance and overlap.

Re-run the tape and manually project the slides together, making any final adjustments to timing. If your projection equipment is pulse operated you now run through the entire sequence recording the dissolves and changes onto the second (inaudible) track of your tape. The whole show will then run automatically, with sound married to vision. It is time to call in an audience and show your work.

PROJECTS

P10.1 Make a 5–10 min slide/tape sequence on 'The Rush Hour'. Use authentic sounds—various kinds of vehicle, voices, feet walking etc—and capture the general confusion and bustle of people getting to or from work.

P10.2 Produce a dissolve slide sequence to accompany one of the following pieces of music: 'Mars' from Holst's Planets Suite; 'L'Apres Midi D'une Faune' by Debussy, or a part of 'Pictures from an Exhibition' by Mussorgsky.

P10.3 Make an audo–visual instruction sequence which clearly and interestingly explains one of the following: (1) making and decorating an iced cake; or (2) constructing a model aircraft; or (3) looking after a domestic pet.

P10.4 Record an interview with an elderly person recollecting your area as it was many years ago. Link this with visuals which include copies of old photographs of the place, as well as close-ups of the speaker today.

P10.5 Choose a narrative or descriptive poem or limerick and present it as a slide/tape sequence.

P10.6 Conduct an opinion poll. Question at least 10 people individually on a topic such as what they think of your school. Seek out the widest possible range of people and opinions. Tape record their *brief* replies and present these with head and shoulder close-ups of each person.

P10.7 Choose a current pop single record and illustrate it with a slide sequence. Use abstract and fantasy images where appropriate.

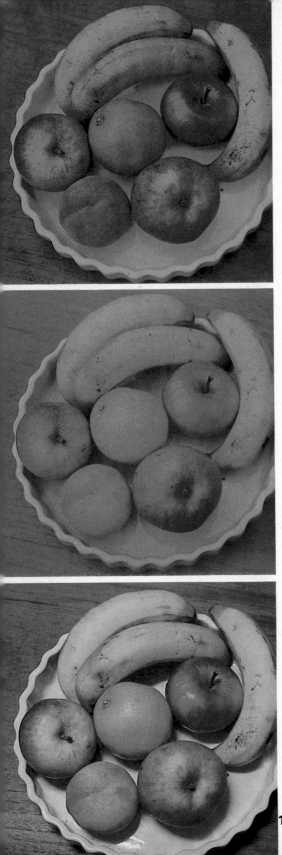

Appendix A
Common colour transparency faults

In most cases errors are due to the wrong colour balance between lighting and film, incorrect exposure, fogging to light, stale film, wrong processing or contaminated solutions. Remember that most colour films have a different appearance when wet, so don't make any final judgement until your film is fully processed *and dry*. A few chemical reducing solutions are now made (e.g. 'Colorbrite') which slightly lighten the three dye layers in an over-dark transparency. You can either reduce one or two layers, affecting colour balance, or all three layers which alters density. However, colour film reducers are expensive and cannot give results as good as accurate camera work and processing. For most transparency faults there is really no remedy—so recognise what went wrong and take avoiding action in the future.

A.1. Photographed on artificial light (type B) film when the subject was illuminated by daylight. Electronic flash or blue tinted flashbulbs would give the same effect. If you bind up the transparency with an orange filter this helps some midtone values but hopelessly tints the highlights. Try to shoot on film balanced for daylight/flash, or use the recommended orange conversion filter (Kodak 85B) over the camera lens, or even use a large sheet of orange acetate to filter the light source.

A.2. Photographed on daylight type film with the subject illuminated by a studio floodlight. Household bulbs give an even stronger orange cast, the lower the wattage the greater the distortion. Binding up with a blue filter will strongly tint highlights. Try to use artificial light film (type A for photofloods, type B for studio lamps, spots etc). Alternatively have a suitable blue conversion filter over the lens, or a sheet of blue acetate over the lamp.

A.3. Here the subject was illuminated by fluorescent strip tubes, and photographed on daylight type film. Many types of fluorescent tube are made, giving different amounts of colour distortion, but generally results are either greenish or bluish. Sometimes a pack of two or three filters can be used over the lens to give considerable correction when shooting. Most film manufacturers supply information. You should check what type of tubes you are using.

Errors in *processing* are mostly due to incorrect timing or temperature, or solutions contaminated when mixing or in use. These give different effects according to film type and brand. Generally variations in first development alter density and contrast; insufficient hardening forms a blue cast; insufficient colour developer gives a weak image warm in colour. Gross processing errors mostly give totally black or clear film; similarly processing in the wrong kit, e.g. attempting to put Kodachrome through Ektachrome chemicals, or reversal processing colour negative film.

If a colour transparency film is accidentally processed in black & white chemicals the resulting black and white negatives can usually be printed (onto black & white paper). But you need a longer than normal printing exposure because the film has an overall stain. N.B. If you accidentally process a colour film such as Ektachrome in black & white chemicals the resulting black & white negative can usually be salvaged to form colour negatives. The film needs a special sequence of bleaching and colour development. Contact the film manufacturers for details.

A.4. Underexposure, by two stops. Colour and detail are acceptable in the lightest parts of the picture, but become lost in the darker, shadow areas. Underexposure also often exaggerates the effect of any incorrect colour balance. (An *overexposed* transparency has bleached highlights, but may have reasonable colour and detail in the shadows).

A.5. Accidentally fogged to a red safelight in the darkroom. This fault is most noticeable in the shadows, and also affects the black edges of the film (not shown here). Make sure *all* safelights are switched off before loading colour film into the processing spiral etc.

A.6. Photographed with a yellow filter (as used for black & white photography) still in place over the camera lens. This happens most often with a direct vision or twin lens reflex camera because the viewfinder does not actually allow you to look through the taking lens.

Appendix B
Glossary

Aberrations. Faults and imperfections in a lens which result in a poor image. Most camera and enlarger lenses consist of several glass elements, designed and assembled to correct the basic aberrations found in a single lens. Generally the less the aberrations the more expensive the lens.

Acidifier (fixing bath). Weak acid (typically potassium metabisulphite) present in a fixing solution to neutralise carried-over developer.

Additive Colour Theory. The formation of a colour image by appropriate mixtures of three primary coloured lights (normally blue, green and red). The basis for several early forms of colour photography and currently used in colour TV. Almost all modern colour films however use subtractive colour systems.

Alkali or Accelerator. An alkali chemical (typically sodium carbonate) included in a developer to increase the activity of developing agent chemicals. The higher the pH of the solution the faster acting and more contrasty the developer.

Angle of View. The extent of the view taken in by the lens. It varies with focal length for any particular format size. Usually expressed as the angle made at the lens across the image diagonal.

Anti-halation Backing. A grey or coloured dye, incorporated between emulsion and film base, or on the back of the film, or within the film itself. Designed to prevent image light passed through the emulsion from being reflected back to give 'halos' around very bright highlights. Usually dissolves during processing.

Aperture (of lens). Size of the lens opening through which light passes. The *relative aperture* is calibrated in *f*-numbers, being the diameter of the beam of light reaching and allowed to pass through the lens, divided into the lens focal length. Widest relative apertures therefore have lowest *f*-numbers. All lenses set to the same *f*-number give images of a (distant) scene at equal brightness.

Artificial light. Generalised term which applies to all man-made light sources, but usually implies electric lamps. See tungsten lamps.

ASA. Stands for the (obsolete) American Standards Association. The initials are now used for film speed as defined by the American National Standards Institute. As printed on a film box the ASA number denotes sensitivity of the film (half the ASA number = half the sensitivity or 'speed').

Bas relief. A print made from a negative which is sandwiched with a film positive (made by contact). The two are bound up slightly out of register. The resulting print looks like a photograph of a low relief surface. See page 87.

'B' setting. Brief or Bulb; on this setting the camera shutter stays open for as long as the release button remains depressed.

Binocular vision. Observation of a scene with two eyes, resulting in a stereoscopic effect. Objects appear solid and three-dimensional.

Bracketing (exposure). Taking several pictures of your subject at different exposure times or aperture settings. E.g. half and double as well as the estimated correct exposure.

Bromide paper. Light sensitive photographic paper for enlarging or contact printing. Carries a silver bromide emulsion, usually with some silver iodide content. Must be handled in darkness or appropriate (usually amber or orange) safe-lighting.

Burning in. Giving additional exposure time to one area of an enlargement in order to make the picture darker in tone.

Camera obscura. A dark chamber to which light is admitted through a small hole, producing an inverted image of the scene outside, opposite the hole. The pinhole camera works on the same principle.

Circles of confusion. Circular patches of light, formed by the lens, representing each point of light on the subject. Unsharp images are filled with large overlapping patches. In a sharp image they are rendered small enough to be acceptable as points.

Close-ups. Photographs in which the picture area is filled with a relatively small part of the subject (e.g. a single head). Usually photographed from close to the subject, but may be shot from further away using a long focus lens.

Close-up attachment. Accessory which enables the camera to focus subjects which are closer than the nearest distance the lens normally allows. An attachment may be a supplementary lens, extension tubes or bellows.

Coating (of lenses). Thin surface coatings of transparent material such as magnesium fluoride to reduce the internal reflection and scattering of light (flare). Often now consist of several layers. Results in an image of improved brilliance and contrast in some circumstances. Originally termed 'blooming'.

Colour balance. A colour photograph which closely resembles the original subject appearance is said to have 'correct' colour balance. Incorrect colour balance (usually due to wrong colour film, or lighting of the wrong colour temperature) gives a cast which shows up mostly in grey tones and pale tints.

Colour temperature. A convenient method of describing the colour content of a 'white' light source. It is based on the temperature (Absolute scale, expressed in kelvins) to which a black metallic body would have to be heated to match the light. E.g. Household lamp 2,800 K, Photoflood 3,400 K.

Compound lens. A lens made up from several lens elements spaced or cemented together.

Complementary colours. Opposite or 'negative' colours to the primary colours of light (Blue, Green and Red). Each is made up from the full spectrum *less* the primary colour, e.g. the complementary of Red is Blue plus Green = Cyan.

Contact printing. Printing with light, the object being in direct contact with the light sensitive material.

Contrast. The difference (ratio) between the darkest and brightest parts. In a scene this depends on lighting, and the reflecting properties of objects. In a photographic image there is also the effect of lens flare, exposure level, degree of development, printing paper etc.

Converter lens. Specially designed compound

lens system intended to attach to an existing camera lens and convert it to longer or shorter focal length. Usually gives poorer image quality than a complete lens of equivalent focal length.

DIN. Stands for Deutsche Industrie Norm (German Industrial Standard). DIN numbers denote a film's relative sensitivity to light, but unlike ASA halving or doubling speed is shown by decrease or increase of the DIN number by *three*. DIN 22 = ASA 125, DIN 25 = ASA 250.

Depth of field. Distance between nearest and farthest parts of the subject sharply imaged at the same time. Greatest with small lens aperture, short focal length, and distant scenes.

Depth of focus. Tolerance in focusing. The amount you can focus a lens backwards and forwards and still form an acceptably sharp image of a subject a set distance away. Often confused with depth of field. Greatest with small lens aperture, short focal length, and close scenes.

Developer. Chemicals, normally in solution, able to convert the invisible (latent) image on exposed photographic material into visible form. Normally does this by reducing the light-struck silver halide grains to black metallic silver.

Developing agents. Chemicals (typically Phenidone, Metol and hydroquinone) able to change light struck silver halides into black metallic silver.

Diffuse lighting. Scattered illumination, visual result is gentle modelling of the subject, with mild or non-existent shadows. Figure 9.12 is an example.

Dodging. Local shading in enlarging, usually by means of a piece of opaque material on a thin wire.

Electronic Flash. Equipment which gives a brief, brilliant flash of light by discharging an electronic capacitor through a small gas-filled tube. Given time to recharge the unit gives many thousands of flashes, usually triggered by contacts within the camera shutter.

Emulsion. Suspension of minute silver halide crystals in gelatine which, coated on film or paper, forms the light sensitive material used in photography.

Enlarger. Optical projector to give enlarged (or reduced) size images which can then be exposed on to light sensitive paper or film.

Enlarging easel (masking frame). Flat board with adjustable blades used on the enlarger baseboard to hold paper flat during exposure. The edges of the paper masked by the blades receive no light, so giving white borders.

Exposed. A light sensitive material which has received exposure to an image. Usually relates to the stage after exposure and before processing.

Exposure. Submitting photographic material to the action of light, usually by means of a camera or enlarger.

Exposure latitude. The amount by which a photographic emulsion may be under or overexposed, yet still give an acceptable image when processed.

Exposure meter. Instrument which measures light intensities falling on, or reflected from, the subject, and indicates corresponding camera settings (shutter speed and lens aperture).

Extension tubes. Rings or short tubes mounted between camera body and lens to space the lens further away from the film and so allow the sharp focusing of very close subjects.

False attachment. A device sometimes used in picture composition. By choice of viewpoint objects at different distances appear to align and run into each other. Can make foreground and background objects appear to be on the same plane, reducing the feeling of depth.

f numbers. See Aperture.

Film speed. Measure of sensitivity of film to light. Usually expressed as an ASA or DIN figure.

Filter, lens. Sheet of grey or coloured (usually dyed) gelatine or glass. Used over the camera lens either to reduce the light (neutral density grey filter) or to absorb particular wavelengths from the light beam. E.g. Yellow filter absorbs some light from a blue sky.

Fisheye lens. An extreme wide angle lens which is not corrected for curved line (curvilinear) distortion. All straight lines except those running through the very centre of the image appear bowed. See page 6.

Fixer. Chemical bath that follows development to make soluble those parts of a photographic image unaffected by the developer. Photograph can thereafter be handled in normal lighting.

Fixing agent. Chemical (usually sodium thiosulphate) able to change silver halides into colourless soluble salts removable by washing.

Flare. Scattered light which dilutes the image, lowering contrast and seeming to reduce sharpness. Mostly occurs when the subject is back-lit, or a compound lens is uncoated, or reflective surfaces occur within the camera body.

Flash. Brief duration light source arranged to produce maximum illumination during the moment the shutter is fully open. Photographic flash units use either an electronic tube (repeatable) or flashbulb (once only).

Flashbulb. Expendable glass bulb containing low pressure oxygen, zirconium wire and ignition filament. Fired by means of a low current from a battery or similar source. Burns out in 1/20–1/200 sec. according to type.

Flash contacts. Electrical contacts, normally within the mechanism of the camera shutter, which come together at the appropriate moment to trigger the flash gun. Diaphragm shutters are normally fitted with X and M contacts (see X/M contacts). Focal plane shutters have X-contacts and often an M or FP contact for flash bulbs.

Flash cube. Assembly of four flashbulbs and reflectors in a common unit, which is simply rotated 90° (sometimes automatically, by spring) between pictures, so allowing four exposures without bulb changing.

Flash factor (guide number). Figure allocated to a flash source denoting light-to-subject distance multiplied by the f number required for correct exposure. E.g. Factor of 110 = 10 ft at f 11 or 5 ft at f 22. If the speed of the film is unquoted, the factor usually refers to ASA 100.

'Flat' images. Images which are low in tonal contrast, appearing grey and muddy.

Floodlamp. Studio lighting unit consisting of a large reflector containing a photolamp or other pearl glass lamp. Gives diffuse lighting.

Focal length. In a simple lens the distance (in millimetres) between lens and position of a sharp image for a subject a great distance away. (In

modern compound lenses measured from the rear nodal point). A 'normal' lens has a focal length approximately equivalent to the *diagonal* of the picture format it covers, i.e. 50 mm for 36 × 24 mm. Typical range of other focal length lenses made for this size camera—21, 28, 35, 100, 135, and 250 mm.

Focal plane. The plane—normally at right angles to the lens axis—on which a sharp image is formed. In the camera the emulsion surface of the film must be in the focal plane at the moment of exposure for a sharp image to be recorded.

Focusing. Changing the lens-to-image (or lens-to-subject) distance, until a sharp image is formed.

Fog. Allowing random light to reach sensitive photographic material, as in opening the camera back accidentally or leaving a packet of paper open. Causes overall darkening of the emulsion when processed. Can also be the result of bad storage, or contaminated or over-prolonged development (chemical fog).

Form. Three-dimensionality. Height, breadth and depth.

Format. Height and breadth dimensions of the picture area.

Glossy paper. Photographic printing paper giving a final gloss surface. Unless resin coated, requires drying in contact with a highly polished surface such as a chrome glazing sheet.

Grade, of paper. Classification of black & white photographic papers by the gradation they offer between black and white. Soft (Grade 1) paper gives a wider range of grey tones than Hard (Grade 3).

Grain. Irregularly shaped microscopically small clumps of black silver making up the processed photographic image. Detectable on enlargement, particularly if the film was fast (say ASA 800 or over) and overdeveloped. Hard paper also emphasises film grain. See page 41.

Guide number. See Flash factor.

Hardener. Chemical able to toughen the gelatine of the emulsion, making it more resistant to damage, particularly in warm processing solutions. Commonly potassium alum.

'Hard' images. Images with harsh tonal contrasts—mostly blacks and whites with few intermediate grey tones.

'Hard' light sources. Harsh source of illumination giving strong clear-cut shadows. Tends to dramatise form and texture.

Hue. The name of a colour (e.g. Red, Green etc) without regard to brightness or purity (saturation).

Hyperfocal distance. Nearest subject rendered sharp when the lens is focused for infinity. Focused for hyperfocal distance depth of field extends from half this distance to infinity. See figure 1.13.

Hypo. Abbreviation of hyposulphite of soda, an incorrect early name for sodium thiosulphate. Remains the popular name for fixing bath.

Incident light attachment. Diffusing disc or dome (usually of white plastic) placed over the cell of an exposure meter to make readings *towards the light source*. Calculator dial is then used in normal way. Gives results similar to readings off an average subject or grey card.

Infinity. A distance so great that light from a given point reaches the camera as virtually parallel rays. In practice, distances of about 1000 times the focal length or over. Written on lens focusing mounts as 'inf' or a symbol like an 8 on its side.

Instant picture film. Special film (e.g. Polaroid) able to give a finished, positive print within seconds of exposure. Jellified processing reagent is automatically spread between the exposed emulsion and a receiving layer. This develops and anchors the negative, then causes the remaining halides (forming a positive image) to transfer to the receiving surface, normally white paper.

Inverse square law. 'When a surface is illuminated by a point source of light the intensity of light at the surface is inversely proportional to the square of its distance from the source'. In other words if you double the lamp distance light spreads over a larger area (as shown below), and illumination drops to $\frac{1}{2} \times \frac{1}{2} = \frac{1}{4}$ of

its previous value. Forms the basis of flash factors and close-up exposure increases. Does not apply to large diffuse sources or the (extremely distant) sun.

Kelvin. Scale used for expressing colour temperature, named after Lord Kelvin. Based on the Absolute temperature scale, equal to degrees Centigrade plus 273.

Large format (cameras). Normally refers to cameras taking negatives larger than 120 roll film sizes.

Latent image. The invisible image contained by the photographic material after exposure but before development. Stored protected from light, damp and chemical fumes a latent image can persist for years.

Lens coating. See Coating.

Lith developer. Extreme contrast developer when used with lith materials.

Lith emulsions. Very high contrast emulsions giving practially no grey tones when processed in lith developer. Most lith materials (e.g. Koda-lith film or LP paper) are orthochromatic, and must be handled under a deep red safelight.

Macro lens. Lens intended for close-up photography, able to focus well forward from its infinity position to image subjects only a few inches away, and designed to give a high quality image at such distances.

Macrophotography. Photography at very close subject range (including the production of an image *larger* than the subject) but without the use of a microscope. See Photomicrography.

Masking frame. See enlarging easel.

Monobath. A single processing solution, able to develop and fix black & white films in one stage. (Fixer component is slower to act than developer). Impossible to overdevelop, but solution only gives one fixed degree of development.

Monochrome. Single coloured. Usually implies

a black image but also applies to one which is toned, e.g. sepia.

Montage. An image constructed by combining what were originally several separate images. Figure 6.8 is an example.

Negative image. Image in which blacks, whites and tones are reversed, relative to the original subject. Colour negatives have the colours represented by their complementaries.

Neutral density filter. A colourless, grey filter used to reduce light without affecting colour values. It prevents overexposure if you want to use a slow shutter speed and/or wide aperture in bright lighting conditions.

'Normal' lens. The lens regarded as standard for the picture format, i.e. having a focal length approximately equal to its diagonal.

Ortho. Orthochromatic photographic materials, sensitive to blue and green (but not red).

Over-development. Too much development may result from developing for too long, at too high a temperature, with too much agitation, or developer too concentrated. This results in excessive density, and exaggerated grain structure in the developed material.

Overexposure. Exposing photographic material to too much light because the image is too bright, or exposure time too long. Results in excessive density in the final image.

Panning. Rotating or swinging the camera about a vertical axis.

Panchromatic. Photographic materials sensitive to all visible colours, recording them as appropriate shades of grey. Should be processed in total darkness or an exceedingly dark safelight. All general purpose films are of this kind.

Parallax error. Differences in an image of a subject formed from two different viewpoints.

Perspective. Principle of representing a three-dimensional scene on a two dimensional surface so that the effect is similar to viewing the original scene from one viewpoint. Achieved in photography mostly through *linear perspective* and *aerial perspective*.

Photoflood. Trade name for type of 3400 K photolamp, i.e. high intensity, short life bulb designed for amateur photography and run directly off the mains. In colour photography suits Type A film.

Photographic lamps. Generalised term now often applied to both 3200 K studio lamps (floods and spots) and the brighter, short life 3400 K photoflood lamps.

Photomicrography. Photography through a microscope.

Polarising filter. Colourless filter which transmits light polarised in one particular plane. By rotating the filter to the best position you may suppress polarised reflections from glass, gloss paint, water, and other non-metallic surfaces and so improve underlying colour intensity. Also darkens blue sky (mostly in area at right angles to line joining sun and camera).

'Pushing'. Slang term for uprating film speed.

Positive image. One in which blacks, whites and tones approximate those of the original subject; or colours are reproduced normally.

Preservative (developer). Chemical (typically sodium sulphite) included in a developing solution to help preserve the developing agents from oxidation.

Printing in. See Burning in.

Rangefinder. Instrument for determining the distance between camera and subject. Often fitted to direct vision viewfinder cameras—a double image is seen in the centre part of the viewfinder, and this merges when the taking lens is set for the correct distance. Single-lens reflex cameras often have split-image or microprism rangefinders in their viewing screens.

Rapid fixer. Fixing bath using ammonium thiosulphate or thiocyanate instead of the normal sodium thiosulphate. Enables fixing time to be greatly reduced, but is more expensive.

Reciprocity law failure. Normally the effect of dim light, or small lens aperture, can be counteracted by giving a long exposure time. But this reciprocal relationship (half the brightness = double the exposure time) breaks down with very long or short exposure times. The film then behaves as if having a lower speed rating. Colour films may also show incorrect colour balance. Begins to occur with exposures longer than 1 sec or shorter than 1/10,000 sec.

Reflex camera. Camera with viewfinder system using a mirror and focusing screen.

Refraction. Change in direction of a ray of light passing obliquely from one transparent medium into another of different density, e.g. from air into glass. The basic reason why lenses bend light rays and so form images.

Replenisher. An appropriate solution added to large tanks of film developer (or fixer) to compensate for the exhaustion of active chemicals which has taken place during processing. Replenishment cannot continue indefinitely because solution life is limited by the quantity of byproducts which accumulate as films are processed.

Resin coated bromide paper. Bromide paper having a water repellant base. As chemicals are not absorbed by the paper base the material requires less washing, dries rapidly and generally processes faster. Typically 1 min dev; ½ min rapid fix; 2 min wash; ½ min to dry. RC paper should be air dried (glossy type has built-in glaze), and requires care in mounting. More expensive than conventional paper.

Reversal film. Film which can be processed to give a positive image direct. Colour-slide films are of this type, and one or two makes of black & white film are also available. Several normal black & white films can be reversal processed, see page 121.

Rollfilm. Photographic film, usually $2\frac{1}{2}$ in. wide (known as 120 or 620) attached to numbered backing paper and rolled on a flanged spool.

Safelight. Darkroom light source filtered to illuminate only in a colour to which photographic material is insensitive. The required colour varies with type of emulsion e.g. dark red for ortho materials, orange for bromide papers.

Saturation. Description of the purity of colour—the more saturated the colour the less it is diluted by white or grey.

Selective focusing. Using a shallow depth of field (i.e. by means of a wide lens aperture) and focusing so that only one selected zone of the subject is sharply recorded. A method of separating out and giving emphasis to one element of a scene. See figure 1.15.

Shading (in printing). Preventing the image light

from acting on a selected area of the picture for a time during the exposure, causing this part to be *lighter* in the final print.

Sheet film (cut film). Film supplied as individual sheets, usually 10 or 25 to a box. Sheet film is loaded one at a time into film holders and used in large format cameras. Most common sizes: 4×5 in, 5×7 in, 10×8 in.

Shutter. Mechanical device to control the *time* light is allowed to act on the film. Usually consists of metal blades near the diaphragm of the lens, or two blinds passing one after another just in front of the film; the exposure occurring in the gap between them (focal plane shutter).

Silver halides. Light sensitive compounds of silver with the halogens (iodine, bromine etc). Normally white or creamy yellow in colour. Used as the main sensitive constituent of photographic emulsions.

Single lens reflex (SLR). Camera in which the viewfinder image is formed by the picture-taking lens, via a hinged mirror.

Slide copying attachment. Camera attachment for easy copying of colour slides. Typically consists of tube or bellows holding slide at one end, close-up lens at the other. Attached over the camera lens, the whole unit is then pointed towards any suitable light source.

Soft focus. Image in which outlines are slightly spread or diffused.

'Soft' light sources. See Diffuse lighting.

Solarising. Image manipulation by fogging during development. Gives a part-positive part-negative result. See page 88.

Spotlight. Lighting unit consisting of a compact filament lamp, reflector and lens in one housing. Gives hard direct illumination which can usually be varied from narrow to broad beam.

Squeegee. Device using a thick straight flap of rubber or a rubber roller, used for pressing water out of wet prints and squeegeeing them in contact with glazing sheets etc.

Stop-bath. Stage in processing which arrests the action of the previous solution (e.g. a weak solution of acetic acid or potassium metabisulphate used between development and fixation).

Studio lamps. Flood and spotlamps designed to produce light at a colour temperature of 3,200 K.

Subtractive colour theory. A colour image formed by three appropriate superimposed dye images (normally yellow, magenta and cyan). Each dye image subtracts unwanted areas of a primary colour from white light. The basis of most present transparency and neg/pos colour photography processes.

Synchronisation of flash. Arranging that flash and camera shutter fire in unison, so that the shutter is open during the period maximum light is emitted from the flashbulb or tube. See X/M contacts.

'T' setting. Denotes setting position on shutter for time exposures. Pressing the release opens the shutter, which then remains open until pressed for a second time. Found only rarely on modern shutters.

Telephoto lens. Long focus lens of compact design (lens is physically shorter than its focal length).

Test strip. One or a series of test exposures on a piece of film or printing paper, which is then processed to see which gives the most satisfactory result.

Texture. Surface qualities such as roughness, smoothness, hairiness etc.

Through-the-lens metering. Measuring exposure by a meter built into the camera body, which measures the intensity of light passing through the picture-taking lens.

Time exposure. A long duration exposure. Usually refers to a period longer than the slowest speed the shutter mechanism offers, i.e. over 1 second.

Tones, tone values. Areas of uniform density in a positive or negative image which can be distinguished from darker or lighter parts. Tone values in a final photograph are influenced by film contrast, degree of exposure and development, paper grade etc, as well as subject and subject lighting.

Translucent. Transmitting but also diffusing light, e.g. tracing paper.

Transparency. Positive image on film.

Tungsten lamps. Lamps which generate light when electric current is passed through a fine tungsten wire. Household lamps, photofloods, studio lamps etc are all of this type.

Twin lens reflex. Camera design using two lenses—one forming an image onto film, the other giving an image on a focusing screen.

Type A colour film. Transparency film balanced for photoflood (3,400 K) lighting.

Type B colour film. Transparency film balanced for 3,200 K studio lighting.

Uprating. Shooting film at more than the manufacturer's suggested speed rating, e.g. exposing 400 ASA film as if 800 ASA. The film is then given extra development. (There is a distinct limit to the degree of uprating possible before image quality suffers, i.e. development cannot fully compensate for underexposure.)

Underdevelopment. Giving too short a developing time; using too low a temperature, too great a dilution or old or exhausted solutions. This results in insufficient density being built up.

Underexposure. Exposing photographic material to too little light, because the image is too dim or exposure too short. Results in insufficient density in the final image.

Viewpoint. The position from which camera, and photographer, view the subject.

Wetting agent. Chemical (e.g. weak detergent) which reduces the surface tension of water. Helps even action of developer, and in the final wash water aids drying.

Wide angle lens. Lens with a focal length much shorter than the diagonal of the format for which it is designed to be used. Gives a wide angle of view and considerable depth of field at quite wide apertures.

X/M contacts. Two flash contacts within a camera shutter. The X-contact is used to trigger *electronic* flash the moment the shutter is fully open. The M-contact closes before the shutter completely opens, allowing time for *flashbulbs* to ignite and reach full light output.

Zoom lens. A lens which offers variation of focal length (without altering focus or f number setting). The zoom range—maximum to minimum focal length—is often rather limited, to reduce lens size and avoid introducing excessive aberrations.

Appendix C
Useful calculations and formulae

Working close-up
1. Exposure increase needed when working close-up using bellows or extension tubes. Owing to the inverse square law, when the lens is much further from the film than its infinity focusing position the image becomes considerably dimmer. Unless you are using a meter which measures through the lens, increase exposure as follows:

Multiply exposure by $(M + 1)^2$

Or you can get the same result by multiplying exposure by V^2/F^2.
2. To calculate the distance needed between lens and image to sharply focus at a particular magnification

$$V = (M + 1)F$$

where $M = \dfrac{\text{Height of image}}{\text{Height of subject}}$

V = Distance between lens and image

F = Focal length of lens

Example. You are photographing a 30 mm high postage stamp so that it appears 15 mm on the negative. Using a separate meter the suggested exposure is 1/5 sec at $f8$. The exposure really required at $f8$ is

$$1/5 \text{ sec} \times (\tfrac{15}{30} + 1)^2 = 1/5 \times (1\tfrac{1}{2})^2$$
$$= 1/5 \times 2.25 = .45 \text{ or } \tfrac{1}{2} \text{ sec.}$$

Example. How far from the film must a 50 mm lens be positioned to give an image twice the size of the subject?
Distance required = $(\tfrac{2}{1} + 1)50 \text{ mm} = 150 \text{ mm}$.

Example. How far must the 80 mm lens on your enlarger be raised above the masking easel to give a 240 mm × 360 mm enlargement from a 24 × 36 mm negative?
Distance needed = $(\tfrac{360}{36} + 1)80 \text{ mm}$
$= 11 \times 80 \text{ mm} = 88 \text{ cms}$.

Sepia Toner

(Carried out in normal room lighting.)
Bleach* for 2–3 mins using a solution of 30 grams potassium ferricyanide and 20 grams potassium bromide in one litre of water.
Rinse 1 min.
Tone for 5 mins in 20 grams sodium sulphide in one litre of water.
Wash for 20 mins.

Reversal processing (page 42).

This produces direct black & white positive transparencies from most fine grain black & white negative films, and line films.
Stage 1. First development. Use MQ or PQ type negative developer at four times normal strength, plus 3 grams sodium thiosulphate (hypo) crystals per litre. Typical development time (Pan-X rated at 80 ASA) 12 mins at 20°C. For line films use line developer (page 40) plus 4 grams hypo per litre. Water wash for 3 mins.
Stage 2. Silver bleach*. 2.5 grams potassium bichromate in one litre of water with 2.5 cc of conc. sulphuric acid added (always add acid gradually to water, never the reverse). Dilute this solution one part with nine parts water and bleach for 6 mins. Water wash for 3 mins.
Stage 3. Clearing the bleacher stain. 2.5 grams sodium sulphite and .05 gram of sodium hydroxide* in one litre of water. Clear for 2 mins. Water wash for 2 mins.
Stage 4. Fogging exposure. Place film spiral in a white bowl filled with water, 30 cms below a 100 watt lamp. Expose for about 1 min. (All following stages can take place under room lighting, with the tank lid off.)
Stage 5. Blackening remaining halides. Give about 5 mins in MQ or PQ developer (Print developer will do). Use line developer for line film.
Stage 6. Fixing. Normal acid hardening fixing bath. 10 mins. Water wash 30 mins.

*Ferricyanide (Farmers) Reducer**
(Carried out in normal room lighting.)

Prepare two solutions. 2,5 grams potassium ferricyanide in one litre of water and 40 grams sodium thiosulphate (hypo) in another litre of water. Combine the two just before use—this then lasts about 15 mins. Swab over or immerse the image, and immediately rinse. See how much the picture has lightened, and repeat until correct.

For formulae of developers and fixers see pages 40 and 41.

* Slightly poisonous or corrosive, take care.

Appendix D
Selected books on photography

GENERAL REFERENCE (Library)

Technical:
Focal Encyclopaedia of Photography. Desk Edition, Focal Press 1972.
Visual:
Picture History of Photography. P. Pollack Abrams (N.Y.)* 1970.

INTRODUCTORY BOOKS (Low Cost)

How it Works—The Camera. D. Carey Ladybird Books 1970.
Pocket Money Photography. C. Wright Paperback ed. Pan Books 1975.
Photography. R. Greenhill *et al* Macdonald Guidelines 1976.
Starting Photography. M. Langford Focal Press 1975.
Basic Still Photography (Free booklet) Kodak Ltd.
How to Make Good Pictures. Kodak Ltd.

BASIC TECHNICAL BACKGROUND

Basic Photography. M. Langford Paperback ed. Focal Press 1977.
Camera and Lens. Time/Life Library of Photography 1972.
101 Experiments in Photography. Zakia & Todd Paperback ed. Fountain Press 1970.
Commonsense Photography. L. Grant Focal Press 1973.
Photography. Upton & Upton. Brown* (U.S.A.) 1976.

FOR PARTICULAR PRACTICAL ASPECTS

Color. Time/Life Library of Photography 1973.
The Studio. Time/Life Library of Photography 1973.
The Print. Time/Life Library of Photography 1973.
Introducing Photograms. P. Braundet Batsford 1973.
Developing, Printing, Enlarging. Kodak Ltd.
Principles of Composition in Photography. A. Feininger. Paperback ed. Thames & Hudson 1973.
Slide, Tape and Dual Projection. R. Beaumont Craggs. Focal Press 1975.
Zone System Manual. A. Adams*. Paperback ed. 1975.
Lighting for Photography. W. Nurnberg. Focal Press 1970.
Effects and Experiments in Photography. P. Petzold. Focal Press 1973.
The Focal Guide to Colour. D. Lynch. Focal Press 1976.

HISTORICAL BACKGROUND

A Concise History of Photography. H. Gernsheim Paperback ed. Thames & Hudson 1969.
'Click'—A Pictorial History of Photography. Golden Hands Books. London 1974.
The First Negatives. Science Museum Booklet. H.M.S.O.
Cameras. Science Museum Booklet. H.M.S.O.

(Sound Film Strips)
History of Photography. Visual Publications London 1978.

FOR MEDIA STUDIES

Scoop, Scandal & Strife (History of British newspaper use of photography). Lund Humphries 1972.
Photographers on Photography. (Unillustrated essays). Paperback ed. Prentice Hall* U.S.A. 1968.
Photojournalism. Time/Life Library 1973.
Images of Man (Slides of the work of Robert Capa, H. Cartier Bresson etc. with the photographer's own comments recorded on tape). Scholastic Souvenir Co.* U.S.A. 1972.

FOR VISUAL STUDIES

Form in Art and Nature. Ed. G. Schmidt. Basiluis Presse, Basel 1960.
Basic Design. M. Sausmarez. Paperback ed. Studio Vista 1974.
Looking and Seeing. Series of paperback workbooks. Kurt Rowland, Longman 1974.
Eye & Brain. R. Gregory. World University Library 1970.

CAREERS GUIDANCE

Professional Photography. M. Langford. Focal Press 1974.
Choice of Careers Series No. 115. H.M.S.O.
101 Careers in Photography. B. Hudson. Paperback. Longman Green 1972.
(Also publications by the Institute of Incorporated Photographers. Amwell End, Ware, Herts).

COLLECTIONS OF PHOTOGRAPHS FOR DISCUSSION

The World of Cartier Bresson. H. Cartier Bresson*. Thames & Hudson 1968.
The Eloquent Light. (Work of Ansel Adams) N. Newhall. Sierra Club* 1963.
Family of Man. Sandburg/Steichen* Paperback ed. Maco Corp (U.S.A.) 1956.
The Destruction Business. D. McCullin. Paperback ed. Open Gate Books 1973.
Portraits of Greatness. Y. Karsh. Nelson 1964.
Self Portrait. L. Friedlander*
Paperback ed. Aperture 1971.
Jerry Uelsmann. J. Uelsmann*
Paperback ed. Aperture 1970.
The Americans. R. Frank*
Paperback ed. Aperture 1972.
The Creation. E. Haas. Viking* 1971.
East 100th Street. B. Davidson Harvard University Press* 1970.
Painting, Photography, Film. L. Moholy-Nagy M.I.T. Press* 1967.
Shadow of Light. B. Brandt 1977.
Paul Strand, A Retrospective Monograph. Aperture* 1972.
Edward Weston, Photographer. Aperture* 1965.
Creative Camera Yearbook. Coo Press. London.

*Distributed in Britain by The Photographers Gallery, Newport Street, London, W.C.2.

Appendix E
How they were taken

Further technical information on some of the pictures used in this book. Unless otherwise stated all pictures were exposed on 400 ASA film (black and white); or daylight type transparency film 64 ASA (colour); using a 35 mm camera fitted with a normal angle lens.

P.6 This fisheye lens fits on a Nikon single lens reflex camera body. The man in the picture held the camera about 5 cms from his open mouth. The wall behind him was one straight line. Note the immense depth of field, reaching from a few centimetres to infinity. 1/125 sec at f 11.

P.9 All three pictures have the same number of squares in the foreground, but the close viewpoint (wide angle lens) gives steepest perspective lines. Although each was taken at f 8 notice from the appearance of distant background detail how the wide angle lens gives greatest depth of field, and the long focus lens the least.

P.10 In figure 1.9 the sleeping figure was about one metre from the camera, background group ten metres. In figure 1.10 nearest figures were about 25 metres, furthest figures 35 metres. Relate this to the diagram on page 64.

P.12 Figure 1.14 was taken using the depth of field scale for this lens. By focusing for 4 metres depth of field extended from 2 metres to infinity.

P.14 Figures 1.17–19. Taken with a hand-held camera, so a shutter speed of 1/125 sec was chosen, at f 2. The most practical way to focus under these conditions, using extension tubes, is to look through your SLR viewfinder and move the whole camera slowly in towards your subject until the image becomes sharp.

P.15 Shift lenses for 35 mm cameras are expensive, but you can always use a normally mounted wide angle, keep the subject near the top of the negative and then enlarge only this half. Also try tilting the enlarging easel. This corrects verticals but rather elongates shape.

P.18 Exposure read from the side of the pepper facing the camera. Top picture f 16, centre f 8, bottom f 5.6, all at 1/5 sec. Tungsten light film.

P.19 Exposure measured from the sky alone, since detail here was important. 1/125 sec f 11.

P.20–21 Exposure was read by averaging readings from light and dark areas of the chicken's body for each picture. Mostly 1/15 sec at f 11 on 125 ASA film.

P.22 The floodlight fill-in version would have given best results if these had been black and white pictures. Notice the fine highlights it gives to the hair. On tungsten light colour film the fill-in lamp would record correct colour but then the rest of the face appears blue. Both 1/15 sec at f 4.

P.25 Small, self-regulating electronic flashes used at their closest permissible distance can give exposures of 1/10,000 sec.

P.29 Figures 2.31–33 The exposure settings for flash here were (top to bottom) f 5.6, f 11, and f 11. Although the lighting is gentler in the top picture there is a danger of forming 'bags' under the eyes if you bounce too much light off the ceiling and not enough from the wall.

P.31 The patch of light on the background in figure 2.40 is slightly too high. The dark hair seen against the lightest part of the background gives too much emphasis to the top of the head, a shape which begins to compete with the face for attention. All 1/30 sec at f 5.6, tungsten light film.

P.35 Taken in a room lit by one distant fluorescent tube. Note how grain is always most apparent in the grey tones of the image—it becomes hidden in pure black or white areas. A really coarse grain image can be used for photo silkscreen making, see Starting Photography, page 122.

P.37 Figure 3.6. Unfiltered exposure aperture f 16. With green (\times 4) filter f 8. With red (\times 6) filter aperture between f 5.6 and f 8. All at 1/125 sec.

P.38 Overall reading measured from sky, 1/125 sec at f 16. Using \times 6 red filter picture was exposed for 1/125 sec at f 8–f 11. 125 ASA film.

P.41 The magnification here is equivalent to making an enlargement 180 \times 120 cm (70 \times 47 in.) from a whole 35 mm negative.

P.42 The image which has been reduced shows slightly poorer highlight detail and tone gradation, more pronounced grain. This result is acceptable but trying to correct more extreme overexposure greatly increases such side effects.

P.49 Exposures, top left to bottom right, 1/18 sec, 1/15 sec, 1/30 sec, 1/60 sec, all at f 11. Lit by a window on the right, plus a large white reflector board, left.

P.52 Figure 5.1. Exposure readings averaged from face and sunlit chest. 1/250 sec at f 8.

P.53 Figure 5.5. With backlighting like this it is essential to use a lens hood or at least shade the camera lens with your free hand. Otherwise scattered light may flare into the dark areas, turning them grey. 1/250 sec at f 8.

P.56 Figure 5.9. The children pressed their noses hard against square patterned glass. 1/60 sec at f 5.6.
Figure 5.12 Photographed in a cafe, using the camera hand-held at 1 sec, f 5.6. Tungsten light film.

P.57 Figure 5.13. Exposure through the tri-color green filter was 1/60 sec at f 4. When using this film try to pick conditions where sunlight illuminates the foliage direct—shadowed leaves usually record without colouring.
Figure 5.14 When you intend to process colour slide film as a colour negative the ASA speed rating should be doubled.

P.60 Figure 5.16. These crystals (mostly hydroquinone) were formed by rapidly drying a tiny smear of lith developer. Magnification about \times 100, polarising filters above and below the microscope stage.

P.61 Figure 5.19. The lamps along the roof line were imaged to appear just above the bottom of the picture. After a 5 sec exposure the camera was tilted downwards in a series of jerks or short continuous movements, over a period of another 10 secs. Aperture f11.

Figure 5.20. Exposure 1 sec at f2.

Figure 5.21. 2¼ in. sq. camera, 1/10 sec at f22. Exposure was measured by a close-up reading from the water alone.

P.63 Back lighting also contributes to the feeling of depth here. Picture was taken from under an arch, which effectively shaded the lens. 1/250 sec at f16.

P.65. No U-V filter was used for this picture—the furthest hills are therefore rather lighter and much bluer than they appeared to the eye. See text on page 37. A colourless ultra-violet absorbing filter is useful for colour photography where you need to avoid blue casts in distant landscapes, although in this case it would have destroyed some of the depth.

P.66 Figure 6.4. Photographed from the other side of the road—the tower block being about 250 metres further away than the wall.

P.68 Figure 6.8. When finished this montage was about 120 cm (4 ft) square.

Figure 6.10. Exposure was based on a general, overall meter reading—highlights and shadows being about equal in area. 1/125 sec at f8.

P.70 Figure 6.12. Deep yellow filter, 1/250 sec at f8. 125 ASA film.

Figure 6.14. Wide angle lens. Lit by diffused daylight from a large window behind the camera, ¼ sec at f11.

P.73 An exposure of 3–4 secs at f16. The girl was at first stationary but after about 1 second she moved her arms rapidly, waving clear plastic sheeting which reflected the studio lamps. An unlit, black background is essential.

P.75 Figure 7.4. For high key portraits use a light toned background and soft, largely frontal lighting. Don't overexpose. Clothing should be light toned too. Print for lightness and delicacy—don't let the picture appear grey or flat.

Figure 7.5. For a low key effect the opposite requirements apply. Leave plenty of shadow—diffuse side lighting is often ideal. Print for detail in lightest parts of the face and let the rest merge into darkness.

Figure 7.6. The window bars were tiny thin strips of black paper set between the glasses of a slide mount. This was obliquely projected onto the studio wall, using an ordinary slide projector. One reflected floodlight. 1/30 sec at f5.6.

P.77 Figure 7.12. Spotlit from above, rear, plus a flood on the left. This flood was positioned so low it only illuminated the egg. A large white reflector board was held below and to the right of the lens. 1 sec at f22, 125 ASA film.

P.80 Exposure read from the projected image on the hand (don't let the meter cast a shadow) ¼ sec at f4, tungsten light film. To avoid subject movement provide some firm support for the wrist.

P.81 Figure 8.3. You must ensure the room is fully blacked out or your final image will have grey shadows. Camera lens f16 to allow a long enough exposure time (3 secs) for movement of the shaders to blur the edges where the images join. Don't allow the projectors to vibrate.

P.83 Figure 8.7. Thick 'vaseline' smeared over the right half and bottom of the filter. Choose a subject with small, brilliant highlights—these give most light spread.

Figure 8.8. It is very difficult to predict the exact effect zooming will give. (In an SLR camera you cannot even see the image during exposure.) So take several pictures at ¼ or 1/8 sec settings. Use slow film—this was 32 ASA.

P.84 Figure 8.11. Yellow is the normal filter (Kodak No. 12) for use with infra-red Ektachrome. With it the film speed is about 100 ASA, but since there is very little exposure latitude always take several bracketed exposures.

P.85 Figure 8.12. Notice how the line becomes thicker and more 'burnt out' where the movement has slowed up (e.g. near the top of each stroke). At f16 give an exposure time as long as needed to complete the word—here it was 10 secs. Taken in a completely blacked out studio, black background. Try it in the garden at night.

Figure 8.13. This is much easier to do with a direct viewfinder or TLR camera—you don't lose the viewfinder image while the shutter is open. Include lights at varied distances, so the extent of movement differs throughout the picture.

P.86 Figure 8.14. Try to select or make negatives which both need the same grade of printing paper—the cow negative here was really a grade too flat.

P.87 Bas-relief is much easier than it looks. Your basic image should have plenty of detail, e.g. frontal lighting. The contact positive here was made on Kodak Gravure Positive 4 × 5 in. film, processed just like bromide paper in print developer. Make several positives at different exposures, then dry them and see how each looks sandwiched with the original negative.

P.89 The film used for solarising here was Ilford Line Film 4 × 5 in. Keep the original negative well out of the way when you place the developing dish under the enlarger, or it may get splashed. Judge the solarised image against a bright light source—it will be very dense and black.

P.90 Tone separation is quite a technical challenge. The secret is to start with an image with graduated tone, the subject softly lit. You must make each Kodalith positive really contrasty. The final example shown would have looked better if made not from two separations, but three (the third being even darker than figure 20.22). This would result in an extra tone in part of the forehead. Registering devices are not essential. You can just make the three lith positives and print each onto a separate sheet of normal contrast film (e.g. Gravure Positive) developed to give a low contrast, pale grey image. Then sandwich these three sheets together in visual register between two sheets of glass, and enlarge direct from this. Be careful to avoid dust at all stages.

P.99 Figures 9.1–8. From top left to bottom right: Sky and top of building. Sun's rays across sky (exposure measured from blue sky only). Extreme wide-angle picture from ground level, on underexposed infra-red Ektachrome. Next two pictures both hazy daylight, exposure measured by general meter readings. Photograph of crystals taken through microscope. Deckchair shot made on tungsten light colour film in daylight. Final picture, over-cast winter daylight.

P.100–101 In laying out a picture essay often the most complicated pictures look better larger in size than simple ones. There are exceptions, e.g. where you want to give emphasis or impact to one special feature. Note how relationships can be used *within* pictures (the shop window models and passers-by) and *between* pictures (the crowded roofs and the crowded shoppers).

P.102 Figure 9.11. Tungsten light colour film, exposure $1/30$ sec at $f2.8$.

Figure 9.12. With colours and patterns as varied as these doors try to standardise all other factors and conditions. Here the lighting is consistently soft overcast daylight, and the camera viewpoint remains about the same height and distance from each door. Several of these pictures were taken hundreds of miles apart.

P.107 Figure 10.5. Sometimes you do not have time to shoot extra, over-exposed frames to sandwich together for a middle picture such as this one. Alternatively use two projectors to superimpose the first and third transparencies on one screen—then copy this to form the intermediate. See figure 8.3.

P.110 Figure 10.7. Note the use of words which 'add themselves' to an existing title e.g. *John Gray* is followed by *as Jake*. To do this tape down the title card, write and photograph the first words, then write the extra lettering and take the next picture. Provided you used a steady tripod the images should register automatically when projected. These particular titles were made by writing in black ink on white card (green ink for the main title). They were then photographed outdoors on daylight Ektachrome but sent for processing as if colour negative film. This worked out quicker than working with white lettering on black card, and cheaper than buying 35 mm lith film specially for the job.

Index